IMAGES
of America

SUNOL

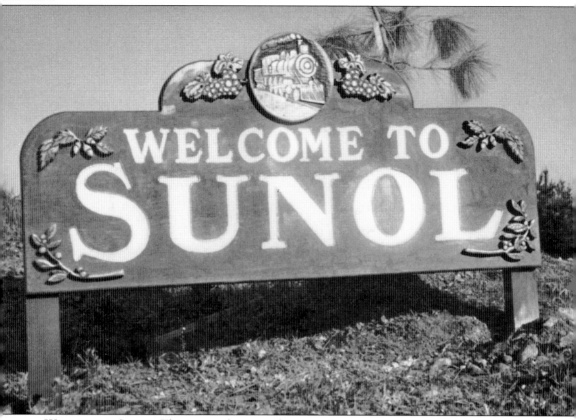

WELCOME TO SUNOL. This is one of two wooden signs that greet motorists entering Main Street from Highway 84 at each end of town. (Courtesy of Ario and Joyce Ysit.)

ON THE COVER: The gentleman in the center of the picture seems a little out of place between the two capped gas station attendants. This photograph, captured at George Schultz's gas station, located at the corner of Main and Bond Streets, represents the character that has always shown the diversity of Sunol. (Courtesy of Bill Rebello.)

IMAGES
of America

SUNOL

Victoria Christian

ARCADIA
PUBLISHING

Published by Arcadia Publishing
Charleston SC, Chicago IL, Portsmouth NH, San Francisco CA

Printed in the United States of America

Library of Congress Catalog Card Number: 2007927053

For all general information contact Arcadia Publishing at:
Telephone 843-853-2070
Fax 843-853-0044
E-mail sales@arcadiapublishing.com
For customer service and orders:
Toll-Free 1-888-313-2665

Visit us on the Internet at www.arcadiapublishing.com

This book is dedicated to my parents, Joyce and Ario Ysit, who have always encouraged my passion to write and have always reminded me of the importance in creating family memories. I also dedicate this book to my daughter Jessica Christian that she may also create family memories to pass on to future generations.

CONTENTS

Acknowledgments		6
Introduction		7
1.	First Settlers	9
2.	A Pioneer's Life	25
3.	The Railroad Arrives	41
4.	Sunol Watershed	51
5.	Downtown Sunol	61
6.	Kilkare Road	75
7.	Old-Fashioned Fun	97
8.	Sunol in the 21st Century	107

ACKNOWLEDGMENTS

In Hawaii, it's called "talking stories"; in Sunol, it is "remembering the past." It is a place you never knew existed and it has been right here all along. If the hills could talk, they would tell of a time of simplicity—no cell phones, no computers, or the traffic nightmare called the Sunol Grade. Thankfully the quaint village of Sunol has remained just that and has not changed much over the years. In this, the 21st century, Sunol residents are continuing to preserve and restore the past, searching again for that simple life.

My experiences in writing this book have been absolutely exhilarating. I've visited countless homes, shared family stories, crawled through dusty attics, played detective and tracked down former Sunolians, spent hours in local museums, and worked on the book until 2:00 a.m. only to dream about it in black and white. But it is that heart-thumping moment when you realize you've found the perfect picture that captures a certain place that makes it all so rewarding.

I hope to have captured the essence of historical Sunol, and I have desperately tried to find and represent in this book everything and everyone that makes the town so special. Of course, I could not have completed this project without the assistance of the following, and I thank them from the deepest part of my heart: my parents, Joyce and Ario Ysit, who have always encouraged and supported my writing ability; my daughter Jessica; partner John Beard; Jovan Beard and Danika Beard, who remained patient with me while I worked on the book; Kathy Morris; Miguel Gerardo LaRosa; William Trimingham; Candace Day; Robert Heath; Sandi Bohner; Henry Luna; Mary Truong; Sara Hansen; Betty Roraback; Joan and Bud Hall; Stanley Garcia; Sam McCracken; Andrea Gronley; Bonnie Bruton; Marie and Lorry Gronley; Derek Johnson; Tim Koopmann; Terry Berry, Cathy Thompson-Maraz, and all the helpful docents at Museum on Main, Pleasanton; Patricia Schaffarczyk and Regina Dennie at Fremont's Museum of Local History; Mary Boyle, reference librarian, Santa Clara City Library; Erica Herron of Sunol Regional Park; and of course my editor, Devon Weston, who guided me every step of the way and shared my enthusiasm for this project.

INTRODUCTION

First discovered by Spanish explorers and missionaries in 1772, the Sunol Valley remained unchanged for nearly 70 years before an acquired land grant was established and the area was named Rancho Valle de San José. The Ohlone Indians who inhabited the valley were quickly displaced as thousands of head of cattle roamed the vast valley floor. When pioneering families started migrating to the area, it was known simply as part of the Murray Township, which encompassed 138 acres of land, one of six townships in Alameda County that was founded in 1853. Over the years, neighboring towns were established, leaving the Sunol Valley the only unincorporated area in the Murray Township.

Although several pioneering families were migrating to California for the famed Gold Rush of 1849, some were just seeking fertile soil and mild climate. They were of varied social levels—farmers, lawyers, bankers, and blacksmiths. The pioneers arrived by ship, traveling from other parts of the country, some "around the horn" of South America, landing in San Francisco Bay; others traveled "over the horn" through the Isthmus of Panama. But most of the pioneers traveled across the country simply by horse, mule team, and wagon.

The town's farmers were self-sufficient, quickly planting crops and building homes. The arrival of the railroad in 1869 changed the town considerably and allowed local farmers to transport their fruits and vegetables outside of the area. The railroad also brought businessmen who discovered Sunol's pristine waters and comfortable weather. Local farmers began selling part of their land to the Spring Valley Water Company, which eventually acquired 40,000 acres of watershed property.

The train also brought city visitors seeking warm weekends in the country. After picnicking and camping in nearby Niles Canyon, folks began building their summer cabins along Kilkare Canyon. Businesses were opened to serve the ever-growing population, the economy was booming, and the town prospered.

The great stock market crash of 1929 and resulting economic Depression of the era brought an end to the town's prosperity. Train ridership decreased; therefore, businesses were closed. However, families from the Midwest were now flocking to California looking for work and a better life.

Sunol's permanent residents were resilient and hardworking and managed to keep living the simple life, but after the end of World War II, the town saw another boom in population. Local military bases were employing soldiers returning from the war, and they were looking for housing. The once summer-only cabins were now being occupied year-round. But there were very few retail businesses in town, and residents were traveling to nearby cities to do their shopping.

The town drifted quietly for several decades until the 1980s. The electronic age of computers arrived, and the Silicon Valley was born. Sunol, located just miles north of the Silicon Valley, meant that residents could easily commute on Highway 680.

The 1980s also brought a newfound community of residents who truly cared about the town and its beautiful surroundings. Nearby cities threatened to annex and take over the town, and residential home developers cast a keen eye on Sunol's vast open land. The 1980s was also a time of community spirit when residents of this unincorporated town elected a Labrador retriever as

their official mayor and a friendly wager turned into an annual event called the Great Sunol Bed Races.

However, townsfolk were faced with tragedy when, within 18 months, three historical buildings in the downtown area were destroyed by fire in the late 1980s. But again residents remained resilient, and a business guild was formed to help revitalize downtown. Rising from the ashes emerged a new building, the largest in town. Trees and flowers were planted, and a new white picket fence was built. The Pacific Locomotive Association acquired right-of-way on the old Southern Pacific Railroad line and soon began attracting visitors to their rolling museum.

As the new century develops, Sunol has remained a close-knit community of residents who all moved here and remain here for the same reason—they simply choose to live in a place seemingly untouched by the outside world, and they are in touch with the natural surroundings the town has to offer.

One

FIRST SETTLERS

After sailing from Mexico north along the Pacific coast and making camp in Monterey, Spanish explorer Capt. Pedro Fages and Fr. Juan Crespi led their expedition north along the coast to San Francisco scouting for a location to build a mission. On their return trip to Monterey, the group traveled inland through the Sunol Valley, and it is believed that Fray Crespi describes Sunol in this excerpt from his journal dated April 2, 1772: "On the other side of the valley we crossed another arroyo even larger, also full of trees. In the southeastern part of this valley the two arroyos unite, and from the junction a good-sized river now flows in the same direction. The place is very desirable for a good Mission, although we did not stop there I named it Santa Coleta."

Fray Crespi had also noted in his journal that they had encountered a Native American village near the Sunol Valley. The Ohlones had settled in the Sunol Valley approximately 250 years ago, and their name is a derivative of a Miwok word meaning "people of the west." The Ohlones were considered the largest population of Native Americans north of Mexico.

Spanish nobleman and San Jose resident Don Antonio Maria Sunol acquired a 48,000-acre land grant on April 10, 1839, with Antonio Maria Pico and brothers-in-law Jose Agostin Bernal and Juan Pablo Bernal, and they named it Rancho Valle de San Jose. Although Sunol's portion of the land grant was considered the largest at 14,000, he chose to remain living in San Jose. Sunol's ranch was located near the current site of the Water Temple.

The pioneering families who arrived in the mid-1880s were heading west for various reasons. Some arrived during California's Gold Rush only to discover the much-sought-after mineral was not as abundant as first thought. Some pioneers chose to follow family members to the golden state, and others had received land grants.

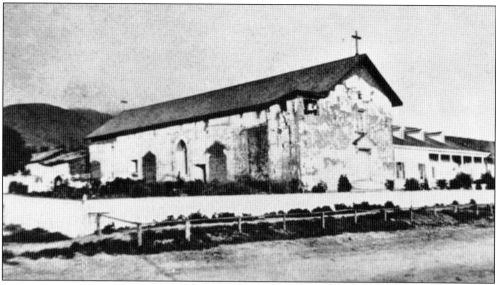

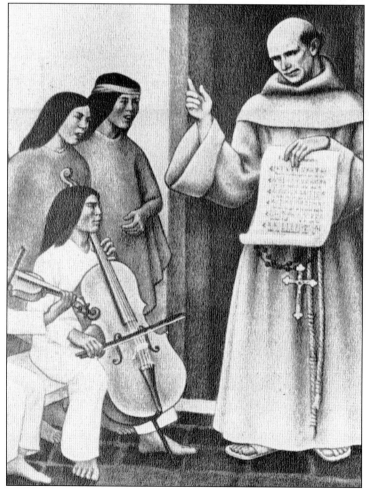

MISSION SAN JOSE, 1867. Founded on June 11, 1797, the acquired lands of La Mision del Gloriosismo Patriarca Senor San Jose, simply known as Mission San Jose, extended far to the north to nearly Oakland and east towards the Sacramento delta region. After secularization in 1836, the land was divided through Mexican and Spanish land grants, and the Ohlones who once inhabited the area were forced to leave. Many of the Ohlones sought shelter at the mission, which is located approximately five miles south of the Sunol Valley. (Above, courtesy of Museum of Local History; left, painting by Edith Hamlin; courtesy of Museum of Local History, R. B. Fischer Collection.)

Antonio Sunol. Antonio Sunol served as San Jose's first postmaster from 1826 to 1829, and he operated the city's first mercantile store from his home. Sunol also held several offices with the City of San Jose, such as trustee, territorial legislator, and San Jose City Council member. Sunol was considered a kind-hearted, generous soul. His favorite flower was the red geranium. (Courtesy of James F. Delgado.)

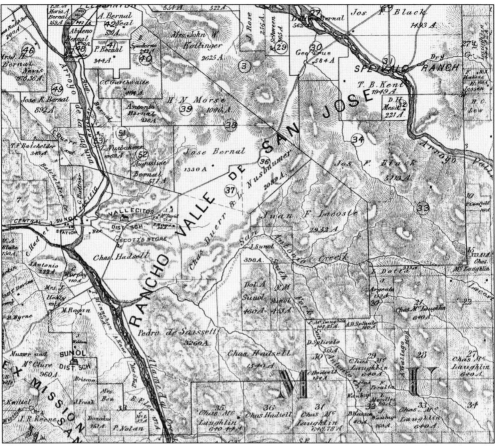

RANCHO VALLE DE SAN JOSÉ MAP, 1878. Because of difficulties with squatters, Antonio Sunol sent his eldest son, Jose Delores Sunol, to manage the ranch, which included thousands of head of cattle and sheep. Unfortunately Jose was shot and killed in 1855 by a squatter, John Wilson, who was found shooting the cattle. Wilson was never captured. (Courtesy of *Thompson and West Atlas*.)

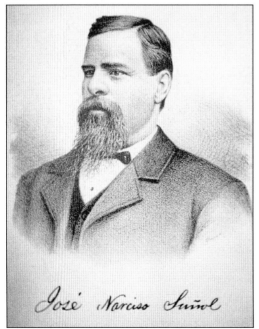

JOSE NARCISO SUNOL. Antonio then sent younger son Narciso to manage the ranch, and he lived there with his family until 1862, when the property was sold to Charles Hadsell for only $5 per acre. Hadsell sold the property to Spring Valley Water in 1872. (Courtesy of Amador–Livermore Valley Historical Society.)

OHLONE RANCHERIA. The last Ohlone ranchero in the Sunol Valley was built in 1860s by the Verona Band, and it was located between Sunol and Pleasanton along the Arroyo De La Laguna Creek. By 1870, the Alameda County Census Bureau reported only 131 Ohlones living in the county. It is believed that the last tribal dance was held in this area in 1897. (Courtesy of Candace Newbern and Robert Heath, Day family descendants.)

BENNETTS ARRIVE IN SUNOL. On April 25, 1868, Jeremiah and Emmeline Bennett and three of their 10 children—James, Susanna, and Annette—traveled by train from Oshkosh, Wisconsin, to New York City, where they boarded a ship to Panama. The group then rode donkeys across the Isthmus of Panama and took another ship arriving in San Francisco on May 23, 1868. (Courtesy of Candace Newbern and Robert Heath, Day family descendants.)

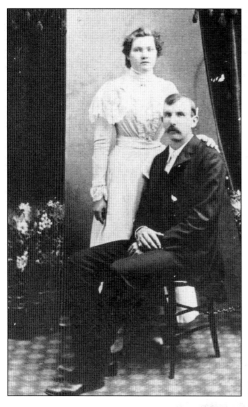

MR. AND MRS. ALFRED BENNETT. The Bennett family joined older son Alfred, who had arrived in Sunol two years earlier. He later built a home on Kilkare Road. (Courtesy of Candace Newbern and Robert Heath, Day family descendants.)

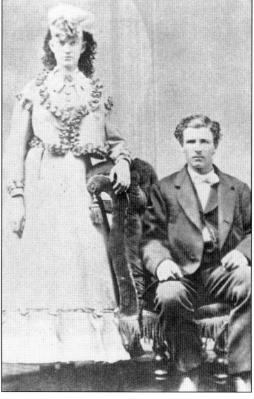

WILLIAM DAY AND ANNETTE BENNETT'S WEDDING DAY, NOVEMBER 5, 1870. The couple, who met in Sunol, was married in San Leandro, and they had 12 children. The Little Brown Church of Sunol's records indicate that William Day was one of the church's first founders, in 1885. (Courtesy of Candace Newbern and Robert Heath, Day family descendants.)

ANNETTE DAY, 1911. This photograph captures a proud moment for Annette when she was on her way to vote in Sunol for the very first time. (Courtesy of Candace Newbern and Robert Heath, Day family descendants.)

RIDING A DONKEY. Family documents indicate that May Day, born in Sunol on May 18, 1896, remembered that all the fireplace chimneys in town were damaged during the 1906 San Francisco earthquake, but she had fond memories of residents from the city arriving by train every summer to camp in Niles Canyon along the Alameda Creek. (Courtesy of Candace Newbern and Robert Heath, Day family descendants.)

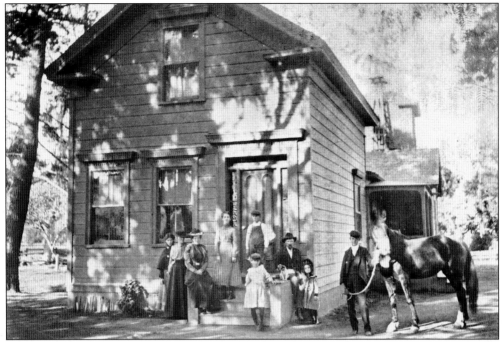

THE DAY FAMILY HOME. The home was originally located on five acres of land between Main and Bond Streets near the Southern Pacific Railroad tracks, but in 1908, the Western Pacific railroad decided to run their tracks almost parallel to Southern Pacific's and bought the right-a-way across the Day property for $4,000. Included in this picture are six of their 12 children. From left to right are Emma, Annette, Aunt Bell, Nell, Earnest, Florence, William, May, Arthur, and their horse, Old Sally. (Courtesy of Candace Newbern and Robert Heath, Day family descendants.)

DAY HOME MOVED. The family home was relocated to Bond Street, and the youngest daughter, May Day, stated that the house was never the same after the move. (Courtesy of Candace Newbern and Robert Heath, Day family descendants.)

SUNOL'S FIRST AUTOMOBILE. William Day proudly shows off his new car. Besides being a successful businessman, Day was also on the board of trustees at Sunol Glen School, one of the founders of the Little Brown Church, and was responsible for the Alameda County Road Maintenance—building and maintaining roads, planting trees, and constructing bridges. After William Day retired around 1912 and moved to San Jose, his sons Frank, Fred, Walter, William, Arthur, and Earnest took over the business, renaming it the Day Brothers. In 1915, Arthur Day and brother-in-law Jesse Hitchcox bought the Day Brothers business and renamed it the Sunol Warehouse Company. They had at one time owned seven large hay warehouses in Sunol. The last 180 acres of the Day family property, which was located north of town near the Hearst Ranch (now Castlewood County Club) in Pleasanton, was sold in 1937. (Courtesy of Candace Newbern and Robert Heath, Day family descendants.)

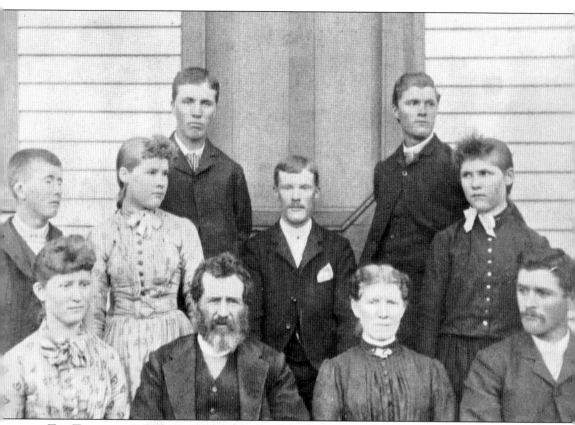

THE TRIMINGHAM FAMILY, C. 1890. James and Augusta Trimingham (seated center) were married in November 1861 and had eight children; pictured from left to right are Henry, Martha, Effie, Frank, Charles, John, Charlotte, and George. They moved in to their Vallecitos Road home in 1866 and eventually moved to downtown Sunol on the property where Sunol Glen School is currently located. All three girls earned their teaching credentials at San Jose Normal School (San Jose State University) and were, at one time or another, schoolteachers in Sunol. (Courtesy of William Trimingham.)

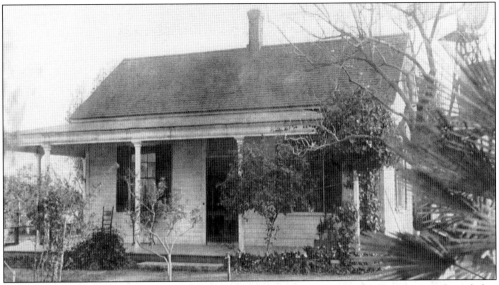

A Move into Downtown, 1930. George Trimingham and his sister Martha purchased this home and land in 1891 for $500; the same year, George married Anna Marie Scharrer. Anna Marie operated a boardinghouse for members of the Southern Pacific Railroad crew and rented the front room to the town's dentist. The couple moved to Pleasanton in 1900. Unfortunately the home on Main Street was burned and destroyed in 1988. (Courtesy of William Trimingham.)

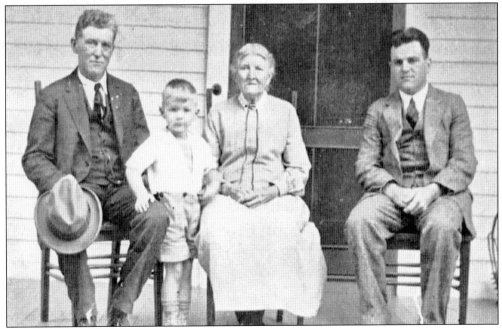

Four Generations of Triminghams, 1927. After her husband, James, passed away, Augusta moved into the family home on Main Street, where the large family gathered during the holidays. Charlotte Trimingham's son, William Henry Lawrence, was a professional baseball player for the Detroit Tigers, and the family enjoyed listening to his ball games on the radio. The family home was finally sold in 1942. Pictured from left to right are George, Robert, Augusta, and Earl Trimingham. (Courtesy of William Trimingham.)

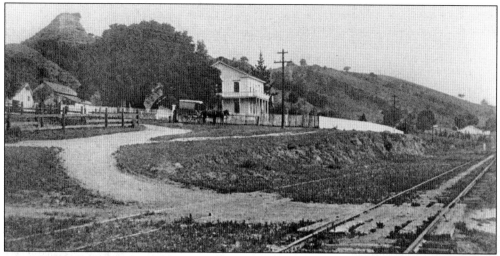

BUTTNER FAMILY HOME. A Spanish land grant of 640 acres persuaded George and Elizabeth Buttner to leave their Kentucky home and travel to San Francisco, arriving in Sunol in 1854. Their first home was a small log cabin. The family then built another home, until the railroad decided to run their track through the property. The house was demolished, and the current larger home was built in 1880. The photograph below shows a bird's-eye view of the Buttner home before the railroad was built. (Above, courtesy of Amador–Livermore Valley Historical Society; below, courtesy of Rebecca Douglas.)

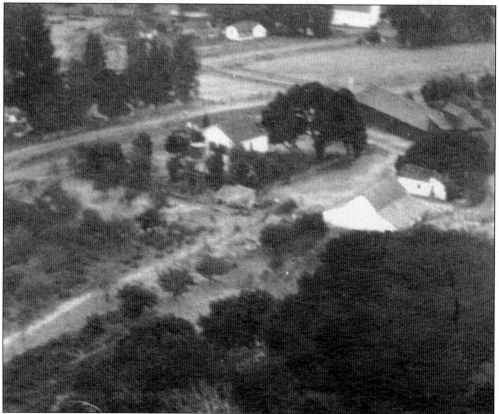

WOMAN OF THE DAY. The Buttner's oldest daughter, Mary "Molly" Buttner, was born in Sunol on January 11, 1861. Never married, Molly was honored on March 2, 1949, as "Woman of the Day" by a national radio broadcast; she was awarded a silver tray from Eleanor and Anna Roosevelt. Molly passed away in the family home on Foothill Road at the age of 93. (Courtesy of Amador–Livermore Valley Historical Society.)

FIRST ALAMEDA COUNTY LIBRARY. In 1910, Molly decided to open up the first-floor front room of the Buttner home as a library. She served for 43 years as the county's first librarian. (Courtesy of Amador–Livermore Valley Historical Society.)

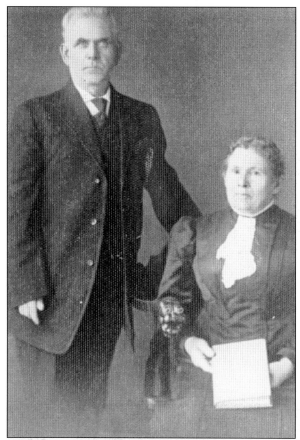

PAT AND MARY ANN GEARY, 1913. In 1865, the Gearys purchased 160 acres of land, for only $2.50 per acre, from the federal government for raising the family, farming, and ranching. The couple raised their 11 children in a small cabin alongside a creek nestled in the rolling hills several miles east of the town of Sunol. This commemorative photograph was taken on their 50th wedding anniversary. (Courtesy of Sunol Regional Park.)

MAURICE GEARY'S HOME. The Gearys' eldest son, Maurice, built this home for his new bride in 1895. After having five children, the couple moved into a larger home a mile away, and his parents then moved into this home. The home, which was destroyed by fire and rebuilt in 1954, is currently used as Sunol Regional Park headquarters. (Courtesy of Sunol Regional Park.)

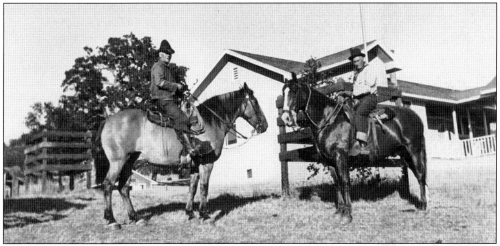

BRINKER RANCH. During the 1930s, Willis Brinker purchased 3,383 acres of land from several families, which formed his one large ranch called the High Ranch. Unfortunately, Brinker was killed in 1959 while fighting a fire on his own property. His land was then purchased by the East Bay Regional Park District in 1959. Pictured above are Willis Brinker (left) and his ranch foreman, Tad Chadborne. (Courtesy of Sunol Regional Park.)

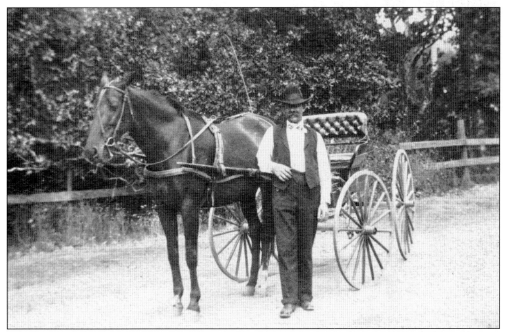

TOWN CONSTABLE, 1912. Alameda County sheriff Lee Graves was living in Sunol when the great earthquake of 1906 occurred. He traveled to Oakland and boarded a San Francisco–bound boat to look for his mother, Mercy Graves. After he found his mother at the waterfront, they traveled back together across the bay and took a train to Sunol. (Courtesy of Joan Hall.)

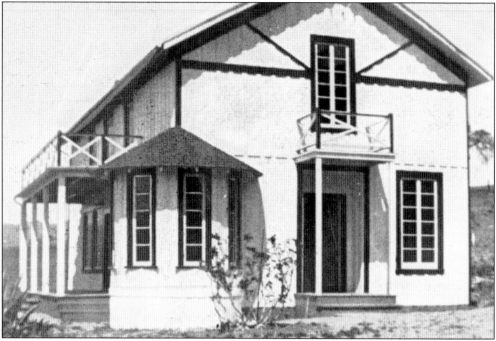

SCOTT'S CORNER. In 1862, George Foscalini built the complex that would famously be called Scott's Corner. It received the name when Thomas Scott purchased the store, thereby calling it Scott's Store on Scott's Corner. The barn-like structure attracted quite a few gunslingers during the late 1880s but was mostly just a dusty stagecoach stop and trading post. Several years later, a garage and service station were added. (Courtesy of Museum of Local History.)

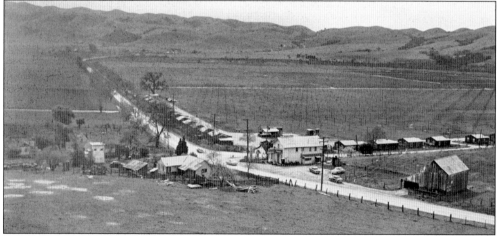

PYE'S CORNER. After quite a few owners and name changes, the corner complex was sold a final time to a Mrs. Pye and her daughter Marie LePleux. One day, as Mrs. Pye was leaving the store and crossing the street towards their home, she was struck by an automobile and killed. During Prohibition, Marie earned money by smuggling 40,000 gallons of wine from the family cellar to the streets of Oakland and selling the homemade brew for 20¢ a gallon. After her mother was killed, Marie LePleux continued running the store until she failed to pay an $80 loan and lost the business. She then moved to San Francisco and went to law school. (Courtesy of Museum of Local History.)

24

Two

A PIONEER'S LIFE

The pioneers who settled in the valley, as well as the Ohlones before them, took advantage of Sunol's fertile soil, fresh water, and mild climate. The major crops being planted in the valley were hay and grain, and on the surrounding hills a variety of fruit and nut orchards were planted. The valley provided well for the residents to live comfortably. During the late 1880s, there were several hay storage warehouses located in the town and two livery and grain businesses. Cattle and sheep were also raised in Sunol. Thousands of head of cattle roamed both the valley floor and hillsides. Livestock corrals were located next to the Southern Pacific depot, and it is said that local ranchers would drive their cattle right down the middle of town on Main Street to be transported by rail.

During the 1930s, the San Francisco Water Department leased their property for most of the town's agriculture crops. The land was rumored to be a 100-acre tract, but it was actually only 94 acres. At one time, it boasted 2,538 walnut trees that produced approximately 120 tons of walnuts during a good year.

Education was important to the pioneers who settled in the Sunol Valley; therefore, wherever a large number of families lived, a school was built. By 1885, there were five separate schools districts within Sunol's boundaries—Sunol School, Vallecitos School, Rosedale School, La Costa School, and Sunol Glen School.

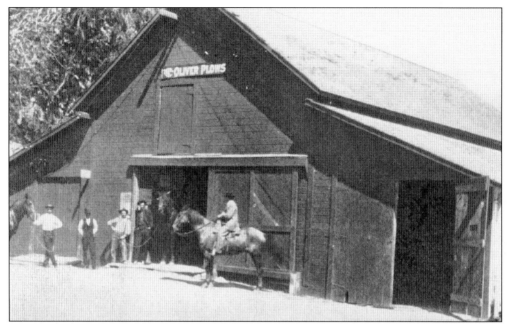

DAY FAMILY BARN. Born in New York on June 20, 1852, William Day moved to California around 1864. After working on a ranch for Charles Hadsell, Day started his own business in 1866 as owner-operator of a livery stable called the Red Barn. (Courtesy of Candace Newbern and Robert Heath, Day family descendants.)

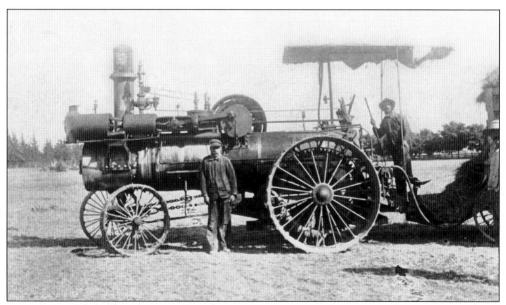

STEAM HAY BALER. By 1891, William Day was a successful businessman, owning several hay and grain storage facilities in Sunol. His business also included commissioning insurance, and he sold farm implements as well as feed and hay. (Courtesy of Candace Newbern and Robert Heath, Day family descendants.)

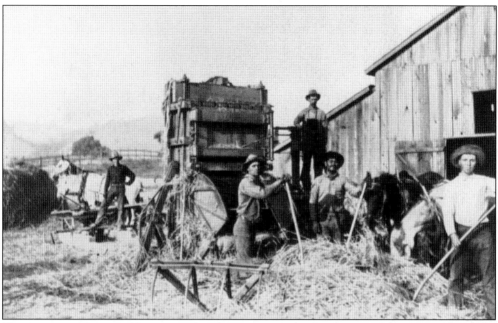

TRIMINGHAMS BALING HAY, 1888 Besides managing the family store, John Trimingham also farmed land he leased from Spring Valley where he grew wheat and barley. He later became a successful businessman who owned a fleet of school buses and gas stations in Sunol, Pleasanton, and Hayward. John Trimingham is pictured second from the left and his brother Frank Trimingham is on the far right; the others are unidentified. (Courtesy of William Trimingham.)

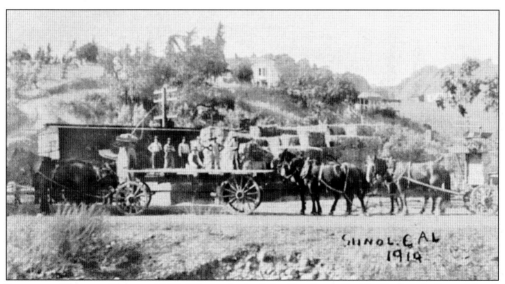

LOADING HAY ON TRAIN, 1919. The arrival of the Southern Pacific Railroad allowed local farmers and ranchers an opportunity to sell hay and livestock wherever the train ran. Hay, being the town's largest crop, was stored in several warehouses around town. Over time, the hay business soon diminished with the invention of the automobile. (Courtesy of Amador–Livermore Valley Historical Society.)

GRACE ELLIOTT. After moving to Sunol in 1908, Grace became the proprietor of Hillcrest Ranch. Grace grew olives, wine grapes, apricots, and prunes; she also raised turkeys and chickens and sold their meat and eggs as well. The only remaining structure on the land is this cabin on the south end of Pleasanton Ridge overlooking Sunol Valley. (Courtesy of Kathleen Elliott.)

TANK HOUSE. Being a single woman, Grace Elliott thought it would be safer to sleep in the tank house for added protection. It was destroyed by fire in the 1980s. (Courtesy of Kathleen Elliott.)

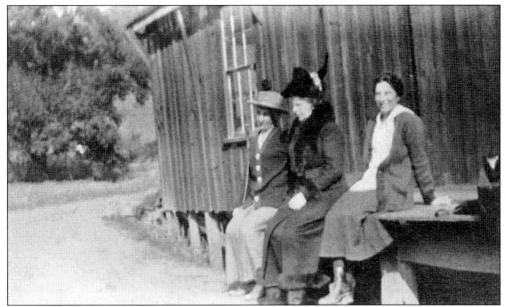

THERMALITO RANCH FRUIT COMPANY. Grace Elliott, pictured at far right, shared her ridgetop land with the Thermalito Ranch Fruit Company, which built this fruit-packing shed. The fruit was packed onto the train for shipment to local communities. Acquired by the East Bay Regional Park District, the ranch land is now called Pleasanton Ridge. Only a small part of the packing shed is still visible today. (Courtesy of Kathleen Elliott.)

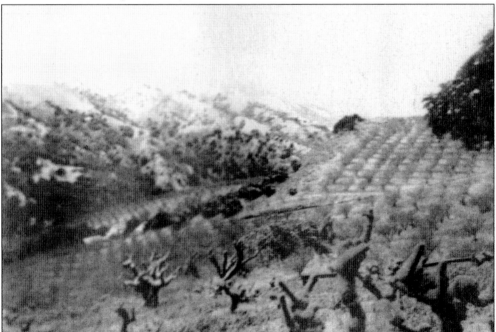

RIDGETOP GROVES. Sunol's ridgetops provided abundant sunshine for growing several different types of crops. Unfortunately, the ranches that operated on these hills have all but disappeared. The only crops visible today are a few olive orchards. The picture above is a rare look at Sunol's snow-covered crops. (Courtesy of Kathleen Elliott.)

AUGUST SCHWARZ. After winning several awards for his hobby of breeding Minorca poultry in his native land of Germany, Schwarz established a poultry farm at his Foothill Road location. (Courtesy of the Gronley family.)

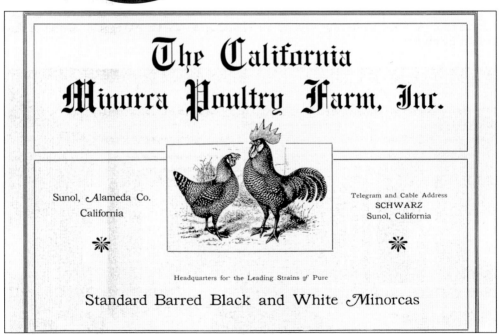

The California
Minorca Poultry Farm, Inc.

Sunol, Alameda Co.
California

✳

Telegram and Cable Address
SCHWARZ
Sunol, California

✳

Headquarters for the Leading Strains of Pure

Standard Barred Black and White Minorcas

CALIFORNIA MINORCA POULTRY FARM ADVERTISEMENT. The farm proudly advertised that "Sunol, Alameda County, Cal, is a place delightfully situated in the mountains and conveniently and quickly reached from either San Francisco or Sacramento. The climate is probably unsurpassed in the world and in every way ideal for poultry culture. The ranch lies on an eminence overlooking a real beautiful valley." (Courtesy of the Gronley family.)

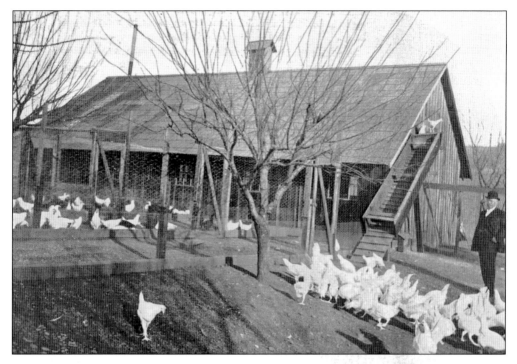

BROODING HOUSE, 1908. August Schwarz's birds were imported from England and Germany. The price for birds of this breed in 1907 were from $5 to $50 each for males and from $3 to $20 each for females. Their fertile eggs were $3 for 12 and up to $20 for 100 eggs. (Courtesy of the Gronley family.)

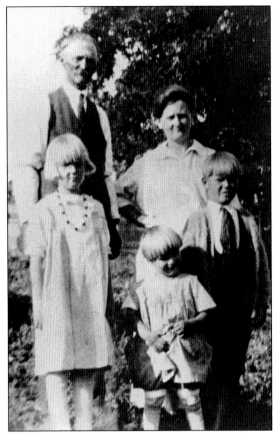

BRASK FAMILY, 1926. Born in Sweden, Paulus Brask arrived in America in the 1890s. After visiting his native country, Paulus was returning from Europe by ship when he met his future wife, Edla. Paulus had owned several creameries in Oakland but, after marrying Edla in 1911, moved to Sunol for health reasons. The couple bought the Minorca Poultry farm in 1912 and moved to their new home in 1914. The Brasks had three children, all of whom were born in this house. Pictured from left to right with their parents are Mildred, Madeline, and Edmund. Unfortunately, in 1926, Paulus was killed in a tragic buggy accident while traveling north on a nearby hillside. (Courtesy of the Gronley family.)

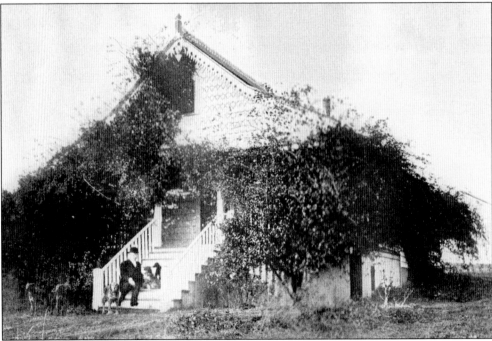

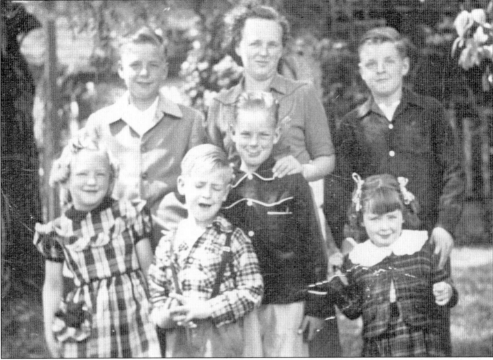

MILDRED GRONLEY AND CHILDREN, 1950. In 1938, Mildred Brask married John Gronley, and they moved into the converted carriage house (shown below) on the Brask farm. When Mildred was eight months pregnant with her sixth child, her husband, John, was killed in a car accident on Niles Canyon Road, leaving her with five children seven years old and under. Mildred lived in the main house with her mother and children and started working just one day a week at Sunol Glen School. She eventually increased her hours to full-time, finally retiring in 1983. Pictured above from left to right are Andrea, Paul, Steven, Lawrence, Mildred, Eric, and Johna. (Courtesy of the Gronley family.)

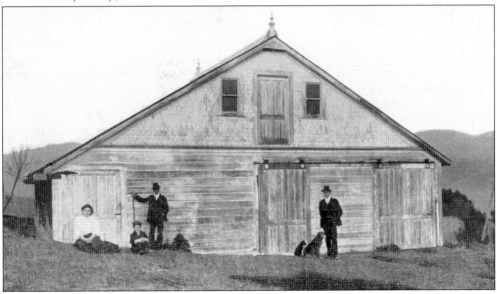

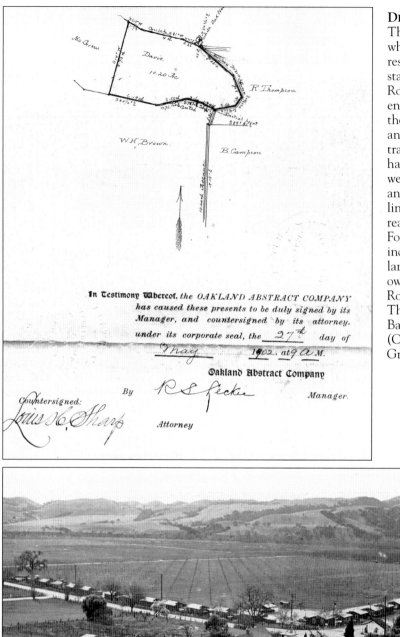

DEED MAP, 1902. This map proves what several residents have stated, that Foothill Road once dead-ended right past the Gronley home, and in order to travel north, one had to climb the west side of the hill and along the ridge line in order to reach Pleasanton. Former deed records indicate that this land was originally owned by a Kilkare Road homeowner, Thomas F. Bachelder. (Courtesy of the Gronley family.)

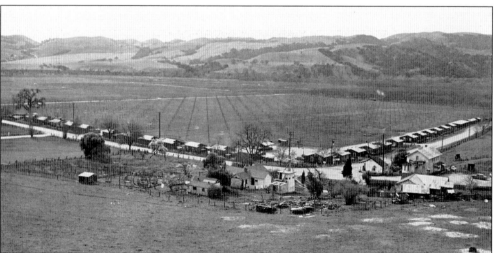

AGRICULTURAL FIELD. During the 1950s, a few Asian American families in town were responsible for most of the agriculture produced on local farmlands. Leased from the San Francisco Water Department, the small homes lining the agricultural fields were occupied by Asian Americans who were farming Sunol's fertile soil. (Courtesy of Museum of Local History.)

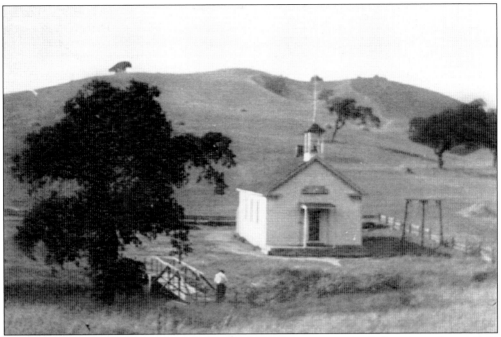

PICTURESQUE SCHOOLHOUSE. Vallecitos School District, pictured above, was located on Vallecitos Road, now known as Highway 84, and was established on July 2, 1868. Sheridan School District, located on Sheridan Road near Mission Pass Road, now known as Highway 680, was established on June 5, 1866. Unfortunately, there is no known image of the school. (Courtesy of William Trimingham.)

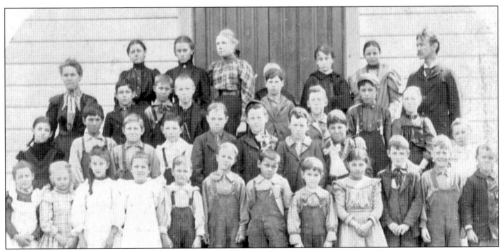

SUNOL GLEN SCHOOL STUDENTS, 1900. Ironically, intern teacher Charlotte Trimingham, pictured in the fourth row, far left, was also a student at this school. Principal Smith is pictured in the fourth row on the far right. (Courtesy of William Trimingham.)

VINTAGE SCHOOL TRANSPORTATION. Patrick William Geary is pictured in front of the Rosedale School with a horse and buggy. Established on November 1, 1875, the Rosedale School District, located several miles east of town, is now within the Sunol Regional Park boundaries. The school's first superintendent, A. A. Moore, named the school after his wife, Rose. Rosedale was combined with Sheridan on December 12, 1910. La Costa School District, also located several miles northeast of town in an area of Sunol called La Costa Valley near the San Antonio Reservoir, was established on May 28, 1883. The area, once an active community, no longer exists and is now part of the San Francisco Water Department watershed. La Costa was combined with Vallecitos on August 28, 1905. There is no known image of La Costa School. (Courtesy of Sunol Regional Park.)

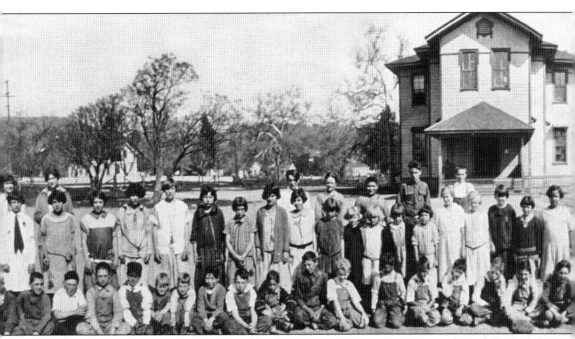

LAST SCHOOL DISTRICT ESTABLISHED, 1865. Located at the corner of Main and Bond Streets, Sunol Glen School District was established on July 6, 1885. Newspaper records indicate that in 1886, Archie Ager, Henry Trimingham, John Trimingham, Mattie Stanborn, Meta Frakes, Frank Day, Frank King, Frank Trimingham, Fred Ager, Lottie Trimingham, Annie Hadsell, Zora Behrens, Dora Sanborn, Daisy Day, Willie Leem, Burr Clary, and Frank Dutra all attended Sunol Glen School. (Courtesy of Amador–Livermore Valley Historical Society.)

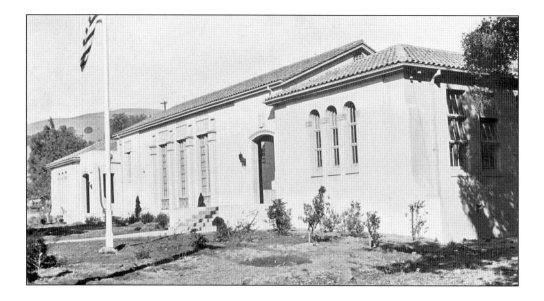

SUNOL'S ONE AND ONLY SCHOOL, 1928. The original two-story Sunol Glen School building, designed by Julius L. Weilbye, was built in 1885. After Vallecitos School and Sheridan School were combined with Sunol Glen on October 14, 1919, a larger school was designed by H. W. Weeks and built in 1925. Pictured below are third-, fourth-, and fifth-grade students. (Above, courtesy of Sunol Glen School; below, courtesy of Bud Meyers.)

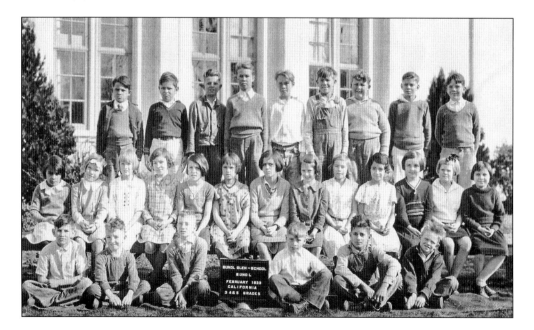

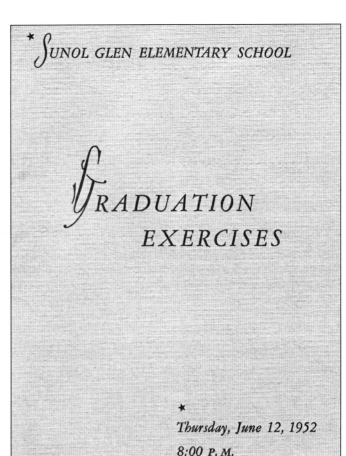

GRADUATION PROGRAM, 1952. There were only seven students in this eighth-grade graduation class, yet there were 18 graduates the following year. (Courtesy of Ario and Joyce Ysit.)

$UNOL GLEN ELEMENTARY SCHOOL

$GRADUATION EXERCISES

★
Thursday, June 12, 1952
8:00 P.M.

Program

Processional . Coronation March
The Star Spangled Banner Music by Mrs. Eldora Peters
Welcome from the Class of '52 Bob Cunningham
Presentation of the Class of '52 Mr. James Howden
Address . Mr. L. W. Reinecke
Presentation of the Class Gift Delmont Baker
Presentation of Diplomas Mr. A. Conrad Westling
Farewell Address . Lee Schenk
Vocal Music Directed by Mrs. Mildred Medsker
Accompaniment by Mrs. Eldora Peters

Vocal Selection Eighth Grade Girls
Solo Bob Hamilton
Vocal Music The Rosealetts

✹

THE GRADUATES

Delmont S. Baker Alice Faye Larson
George F. Baxter Marian Rita O'Laughlin
Robert J. Cunningham Dorothy Ann Salac
 Lee H. Schenk

The Class Play

HER RADIO COWBOY

Directed by Miss Anita Wieking

The Scene: The reception-room at WRIP radio station

THE CAST

William Weston . Lee Schenk
Ed. Galvin . Bob Cunningham
Gracie . Marian O'Laughlin
Dody Barnhill . Dorothy Salac
Mrs. Gussie Barnhill Alice Larson
Jessie Gallup . Carol Ann Peterson
Marylin Meadows . Gloria Perry
Messenger . George Baxter

✹

The Eighth Grade Class wishes to thank Mr. Harry Tripp for his able assistance and many helpful suggestions.

The auditorium was decorated for this evening's program by Mrs. Leona Therkof.

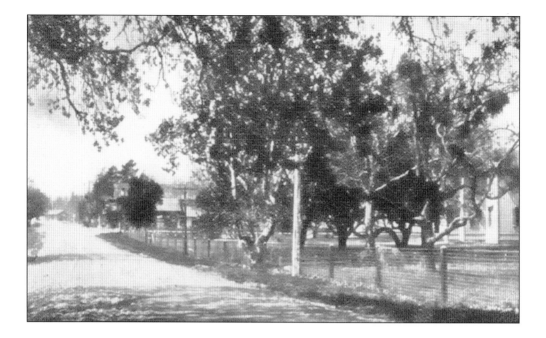

SUNOL GLEN STUDENTS, 1953. The school's grounds remained unchanged until classrooms were added in 1951, 1961, 1966, 1971, and 1990. The school's cafeteria, still in use today, was built in 1958. Pictured below from left to right are (first row) Tom Wofford, Stanley Garcia, Alan Allen, Paul Gronley, two unidentified, Lonnie Larson, unidentified, and John Boscarello; (second row) Betty McCracken, unidentified, Teresa Corege, Geraldine Hall, teacher James Howden, unidentified, Delores Gellerman, Kathy Wooten, Joyce Davis, Gloria Perry, and two unidentified. (Courtesy of Ario and Joyce Ysit.)

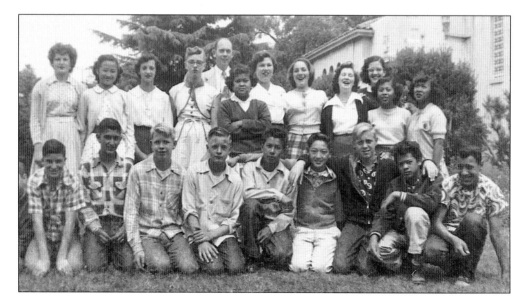

Three

THE RAILROAD ARRIVES

In 1853, Niles Canyon was surveyed as a possible train route to the coast. Pres. Abraham Lincoln suggested building a railway between the Mississippi River and the Pacific coast and favored the route through the canyon, signing the Pacific Railroad Act in July 1862. Founded in December 1862, the Western Pacific Railroad began building a railway from Sacramento to San Jose and a railway from San Jose to San Francisco. The Western Pacific began construction in 1865, but after only 20 miles of track laid, they became bankrupt. In 1868, Central Pacific purchased Western Pacific and began completing the track through Niles Canyon, finishing on September 6, 1869. In June 1870, three small railroads and the Western Pacific Railroad were all combined into the Central Pacific Railroad. After a company reorganization effort, the railroad's name was changed on April 1, 1885, to Southern Pacific. Known as "The Big Four," Leland Stanford, Mark Hopkins, Charles Crocker, and Collis Huntington, of Central Pacific, decided to build the railroad east from Sacramento to meet with the Union Pacific coming west from Omaha, Nebraska. The two railroads met on that historic day at Promontory, Utah, becoming the first ever transcontinental railway on May 10, 1869.

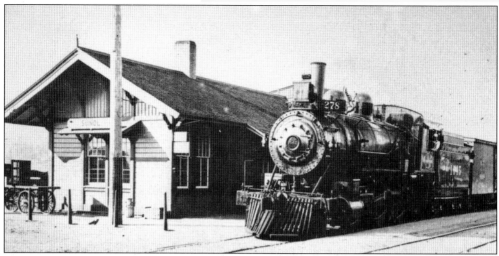

SOUTHERN PACIFIC RAILROAD. Built in 1884, the Southern Pacific depot was moved in 1941 to a different location half a mile west of town next to the Alameda Creek, and at some point, it was turned into a restaurant and then a private residence. Passenger train service was discontinued several years prior. (Courtesy of Bud Meyers.)

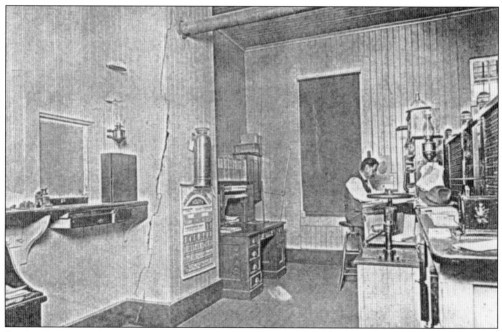

SUNOL DEPOT OFFICE, AUGUST 1913. George Bayley was perhaps the only known agent assigned to the Southern Pacific Depot. (Courtesy of Pacific Locomotive Association.)

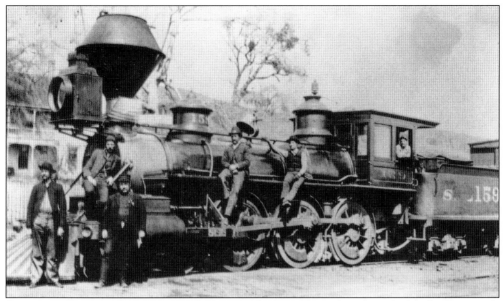

SOUTHERN PACIFIC TRAIN, 1899. The men in this picture are thought to be locals posing with this rare Southern California train. One can just catch a glimpse of the Hazel Glen Hotel in the background. (Courtesy of Amador–Livermore Valley Historical Society.)

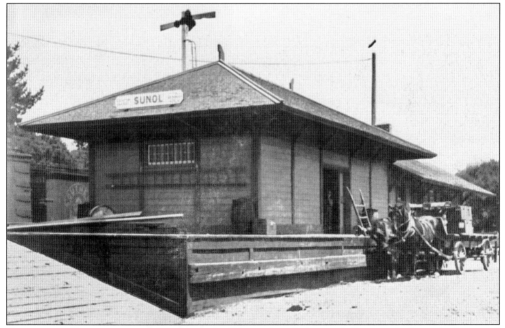

ECONOMIC CHANGE, 1890. The arrival of the railroad changed the town's demographics and economy. Visitors were arriving on a regular basis, some staying permanently. Items could be shipped in and out of town, and local farmers were able to transport and sell their agriculture and stock wherever the train stopped. (Courtesy of Southern Pacific collection.)

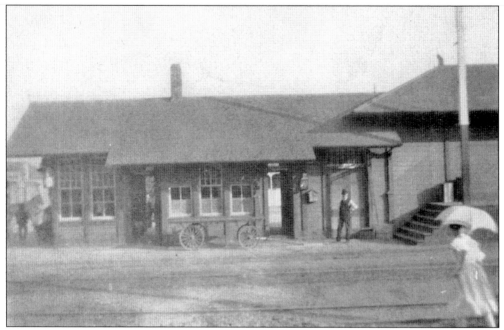

SOUTHERN PACIFIC DEPOT, 1907. The railroad allowed city folks the opportunity to picnic and camp in Sunol and Niles Canyon. Businessmen would later build summer homes in town for their families and would take a train back to the city for the workweek, then return to Sunol on the weekends. (Courtesy of Joan Hall.)

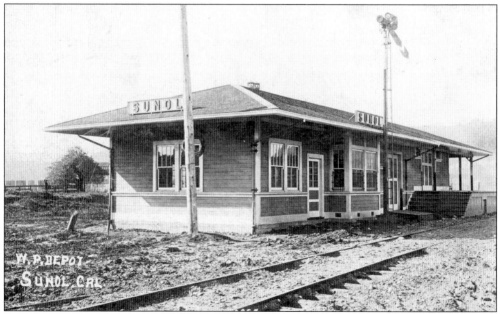

SUNOL'S SECOND TRAIN DEPOT, 1910. In 1909, a second Western Pacific (not related to the previous Western Pacific) railroad line was built on the opposite south side of Main Street, and now there were two trains traveling straight through the middle of downtown Sunol. In 1981, Union Pacific purchased Western Pacific. (Courtesy of Bill Rebello.)

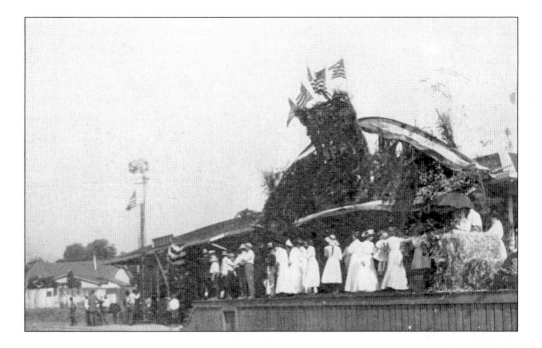

FIRST WESTERN PACIFIC TRAIN. These photographs capture the celebration as the very first Western Pacific train entered the station in Sunol. Unfortunately, the celebration was short-lived. The railroad did not provide enough passenger trains. Therefore, the station was sold, moved to its current location on Bond Street, and remodeled into a private residence. (Courtesy of Bud Meyers.)

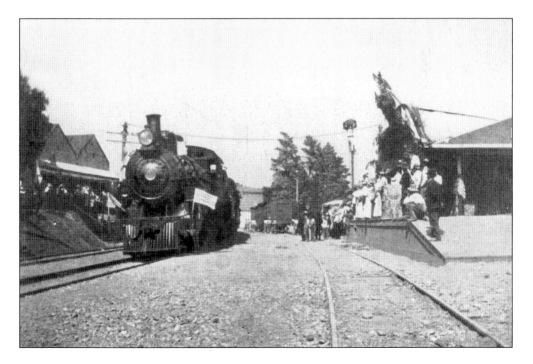

SOUTHERN PACIFIC DEPOT CLOSED, 1941. Unfortunately, the invention of the automobile brought a decline to railroad passenger service and regular visitors to Niles Canyon and Sunol. The once old, dusty Niles Canyon Road was paved in 1928 and became known as Highway 84. (Robert Searle photograph; courtesy of Pacific Locomotive Association.)

WAITING FOR THE TRAIN. Southern Pacific passenger service was eventually discontinued in Sunol. However, trains continued to run through the canyon until 1984 when the company closed; the track was abandoned and the rails were removed. (Courtesy of Rebecca Douglas.)

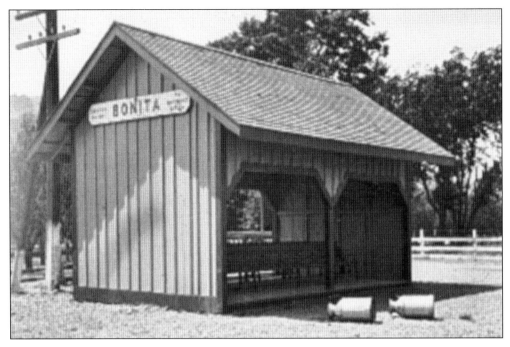

PASSENGER SHELTER. The arrival of the train brought an increase in the number of full-time residents; therefore, several train shelters were built. Farwell, Brightside, and Dresser shelters were located to the west of town in Niles Canyon and Bonita and Verona shelters to the east. The Verona shelter (below) was a private one for Phoebe Hearst, mother to William Randolph Hearst. Phoebe's home, Hacienda del Pozo de Verona, was located in nearby Pleasanton. (Above, courtesy of Southern Pacific collection, Henry Bender photograph; below, courtesy of Candace - Newbern and Robert Heath, Day family descendants.)

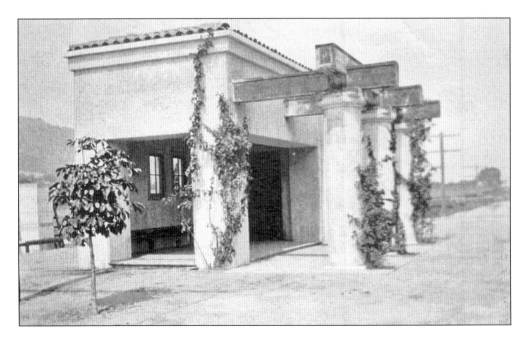

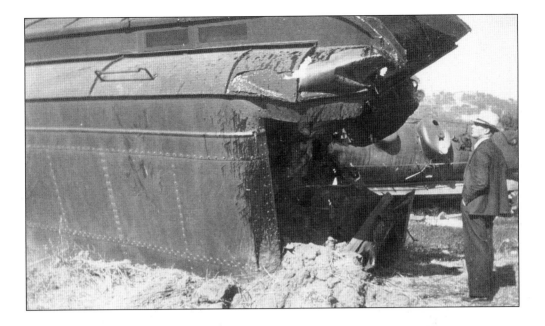

FATAL TRAIN WRECK, SEPTEMBER 1941. A passenger train, the *Chicago Limited*, traveling 36 miles per hour, collided head-on with a steam engine and coal tender two miles east of Sunol. The evening crash killed the passenger train's engineer, fireman, and baggage handler. Seven other passengers were seriously injured. Among those passengers were two army sergeants traveling with prisoners going to Leavenworth Penitentiary. (Courtesy of Bob Athenour.)

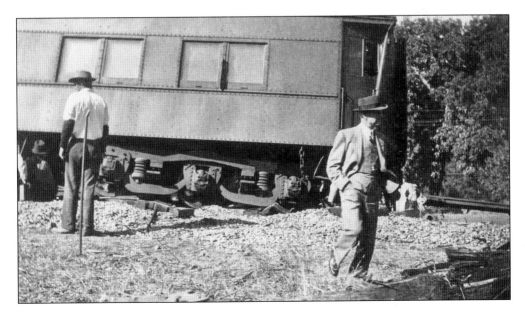

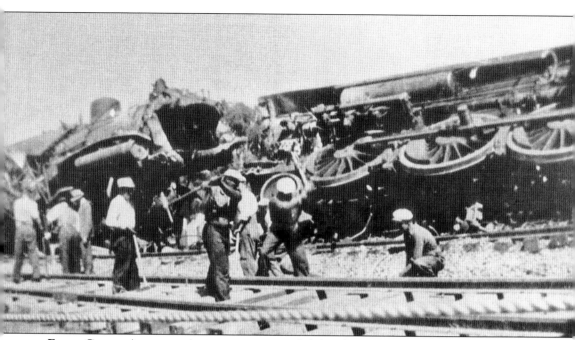

ERROR CAUSED ACCIDENT. An investigation revealed that the cause of the accident was determined to be the fault of the steam engineer's watch being two minutes slow; therefore, the train was not moved to the railroad siding as it should have been. The steam engineer and crew escaped with only minor injuries because they jumped to safety. Local newspapers reported that an onboard nurse and steward assisted passengers while awaiting the Pleasanton Fire Department. (Courtesy of Amador–Livermore Valley Historical Society.)

Four

SUNOL WATERSHED

By the late 1800s, San Francisco's population had grown considerably with the discovery of gold in the Sierra foothills. Good drinking water was so scarce that there were water vendors on every corner, some charging one gold dollar for one bucket of water. San Francisco was continually searching for potable water, and the issue caused even greater concern when the great earthquake of 1906 hit the city and devastating fires burned because of the lack of water.

The Spring Valley Water Company bought watershed property in Sunol in 1872 to provide water to the residents of San Francisco by diverting it from Alameda Creek, in 1888, and from Arroyo de la Laguna Creek, in 1923. The city later purchased the Sunol property for $40 million in 1930.

In 1910, San Francisco residents approved a $45-million bond to begin building their Hetch Hetchy water system, which would provide water from the Sierras near Yosemite. Construction of the O'Shaughnessy dam began in 1917 and was completed in 1923. After laying 160 miles of pipe, San Francisco residents would have fresh mountain water on October 24, 1934.

The City of San Francisco's relationship with the town of Sunol began on March 30, 1930, when they purchased the watershed land in Sunol from Spring Valley Water Company for $40 million. The City of San Francisco's Water Department owns approximately 40,000 acres of Sunol watershed land to this day.

San Francisco city officials further secured their water supply by building two reservoirs near Sunol. The first, Calaveras Dam, was completed in 1925. The second dam is at San Antonio Reservoir, which is located on La Costa Creek and is a tributary of Alameda Creek. The dam is located three miles southeast of the town of Sunol. Water in the reservoir is held by the Turner Dam, which was completed in 1965 at a cost of $9.4 million. The dam is 195 feet high, 2,160 feet long, and 1,075 feet wide. It holds 16.47 million gallons (50,650 acre feet) and has a 40-square-mile watershed. Both the San Antonio and Calaveras Dams provide water storage from Hetch Hetchy Water System for the City of San Francisco and are filtered at the Sunol Valley Water Treatment facility located on Calaveras Road.

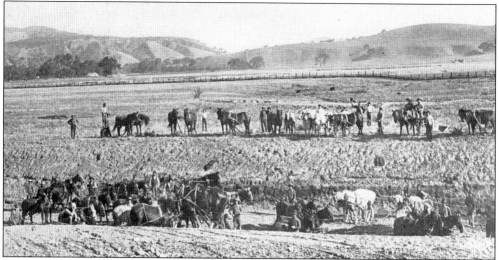

SPRING VALLEY WORKERS LAYING PIPE, 1898. Before the Hetch Hetchy Reservoir and O'Shaughnessy Dam were constructed, nearly half of San Francisco's water passed through the Sunol Water Temple. Now only approximately 15 percent goes to the city; the rest flows back into Alameda Creek. (Courtesy of Museum of Local History.)

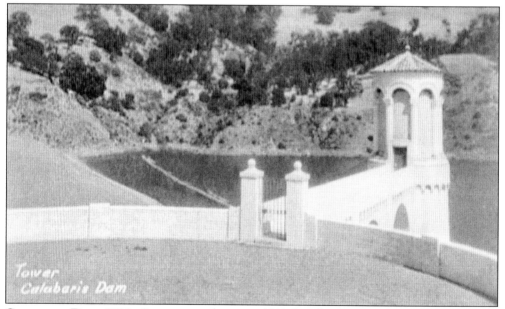

CALAVERAS DAM, 1926. Construction began in 1913, but the face of the dam and water gate tower collapsed on March 24, 1918, and had to be reconstructed. Completed in 1925, the dam is 230 feet high, 1,200 feet long, and 1,500 feet wide at its base. There are 136 square miles of watershed flowing into its reservoir, and the dam holds 31.55 billion gallons of water. (Courtesy of Ario and Joyce Ysit.)

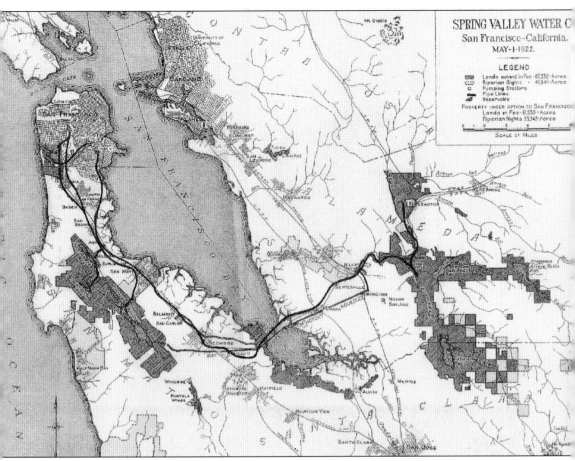

SPRING VALLEY WATER COMPANY MAP, 1922. The darkest shaded areas of this map represent the Spring Valley Water Company's holdings. Sunol is located in the middle of the darkest shade of the wishbone-shaped pipeline on the right. (Courtesy of Earth Sciences and Map Library, University of California, Berkeley.)

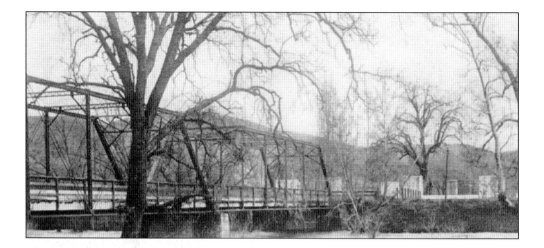

BRIDGE OVER ARROYO DE LA LAGUNA CREEK, 1914 (ABOVE), AND RAILROAD BRIDGE OVER ALAMEDA CREEK, 1914 (BELOW). The water from the two creeks and natural gravel-filtered wells traveled 45 miles by wooden flume through Niles Canyon and continued by pipeline near the Dumbarton Bridge and across the San Francisco Bay. The wooden structure was later encased in concrete and is still visible in some parts of the canyon. (Courtesy of Bud Meyers.)

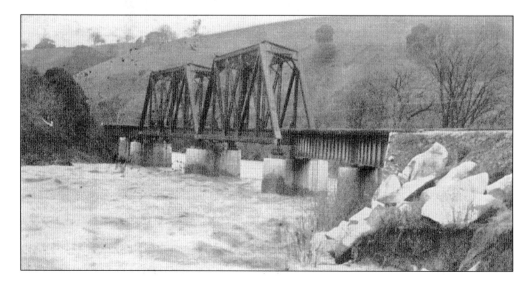

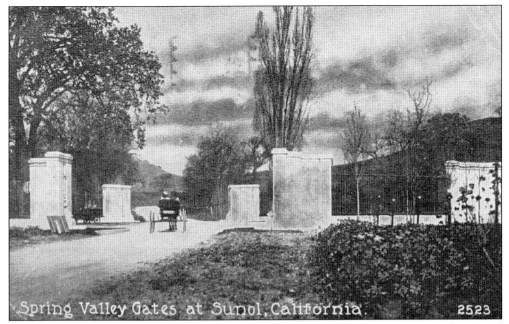

Spring Valley Gates at Sunol, California. 2523

SPRING VALLEY WATER ENTRANCE GATES, 1916. William Bowers Bourn II, who then owned the Empire Gold Mine in Grass Valley, was president and a major stockholder in the Spring Valley Water Company. Knowing that the city of San Francisco would want to buy the Sunol property, Bourn hired prominent architect Willis Jefferson Polk to design the Water Temple in 1909 to sweeten the deal. (Courtesy of Bill Rebello.)

EARLY CONSTRUCTION. After much study and approximately 50 revisions, Willis Polk eventually modeled the Sunol structure after the Temple of Vesta built in the second century BC in Tivoli, Italy. Tivoli is where waters converge near the Apennine Mountains for Rome's water supply. (Courtesy of Lori Nielsen.)

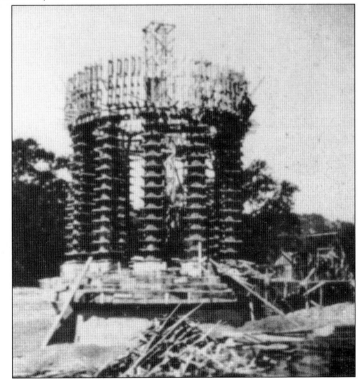

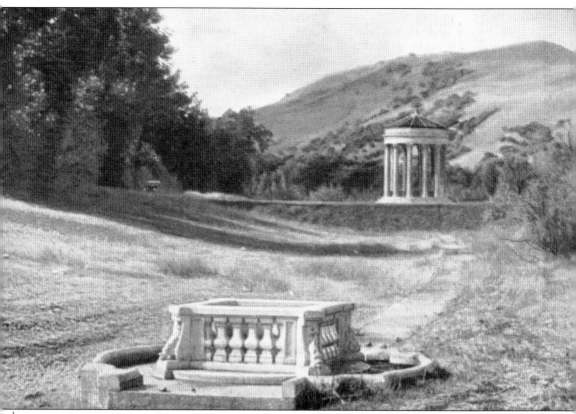

Touching Words. The inscription inside the temple reads: "I will make the wilderness a pool of water and the dry lands springs of water. The streams whereof shall make glad the city. S. V. W. C. MCMX." The initials S. V. W. C. stand for Spring Valley Water Company, and MCMX represents the year 1910. The first line of the phrase is from Isaiah 41:18b, and the second line is from Psalm 46:4. (Courtesy of Amador–Livermore Valley Historical Society.)

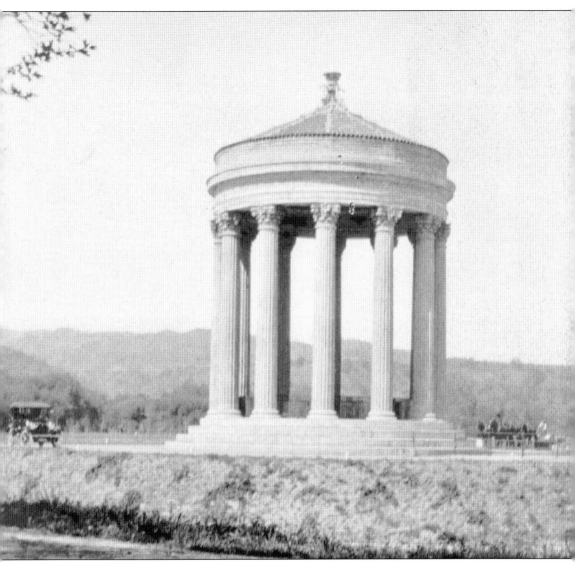

THE WATER TEMPLE. Built in 1910, the breathtaking structure has four steps that lead up to the pavilion's round, white-tiled cistern. Three pipes carrying the confluence of three sources of water—the Alameda Creek, the Arroyo de la Laguna Creek, and the area's well fields—pour into the 40-foot-deep cistern. Twelve Corinthian columns hold the red-clay tile roof, which is adorned with a finial of three copper dolphins. The wood ceiling over the cistern depicts Native American women carrying vessels of water. (Courtesy of Rebecca Douglas.)

BEAUTIFUL NEOCLASSIC STRUCTURE. Willis Polk declared the Water Temple to be his greatest achievement in architecture and chose a line from poet John Keats for the inscription at the base of the temple, which reads, "A thing of beauty is a joy forever; its loveliness increases. It can never pass into nothingness." (Courtesy of Rebecca Douglas.)

WATER TEMPLE IS POPULAR TOURIST SITE. Upon the completion of the Water Temple, visitors flocked by the thousands to marvel at the structure. In early years, the site was a popular picnic spot, and dances were regularly held there. Willis Polk also designed the Pulgas Water Temple in San Mateo County to commemorate the Hetch Hetchy project. (Courtesy of Rebecca Douglas.)

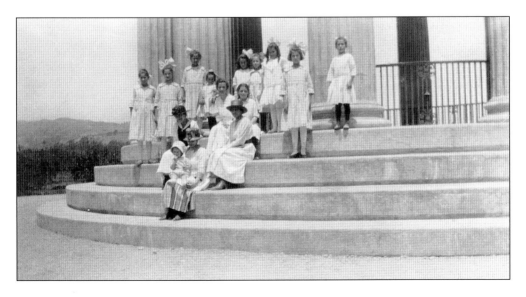

GATES CLOSED AFTER QUAKE. Declared a California Historical Engineering Landmark in 1976 by the American Society of Civil Engineers, the Water Temple was already in a deteriorating state when it was severely damaged by the earthquake of 1989. Once open to the public, the temple gates were closed for safety reasons, and San Francisco city officials wanted to demolish the historic site. (Courtesy of Miguel Gerardo LaRosa.)

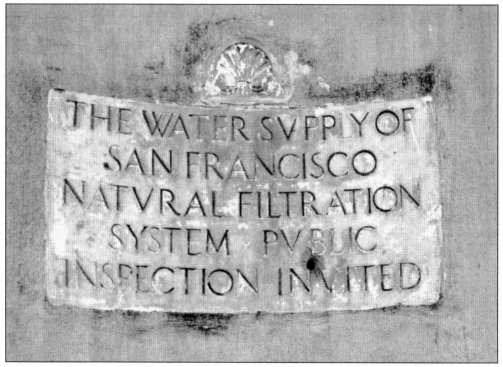

GATE INSCRIPTION. Adorning the front gates of the Water Temple is this inscription that reads, "The Water Supply Of San Francisco Natural Filtration System Public Inspection Invited." (Courtesy of Miguel Gerardo LaRosa.)

Five

DOWNTOWN SUNOL

According to the Sanborn Map Company of New York, in 1908, Sunol had a "population of 200," the "prevailing winds" were "southwest," the water facilities were "not good," there was "no steam and no hand engine," "no independent hose cart," and "no hook and ladder truck." That certainly doesn't sound very inviting. Most of the land was agriculture; therefore, very few residents were living in the downtown area until the arrival of the railroad. When the Southern Pacific and Western Pacific Railroads chose to lay their track right through the middle of town, property was bought and residents were paid to move their homes. The railroad brought city visitors, which increased revenue, and businesses were sprouting faster than weeds. During the late 1800s, there were two hotels, two blacksmith shops, two general stores, a butcher, a livery and feed store, several saloons, a school, a barber, and a post office—all located on or near Main Street. There were approximately five large hay warehouses in and around the downtown area.

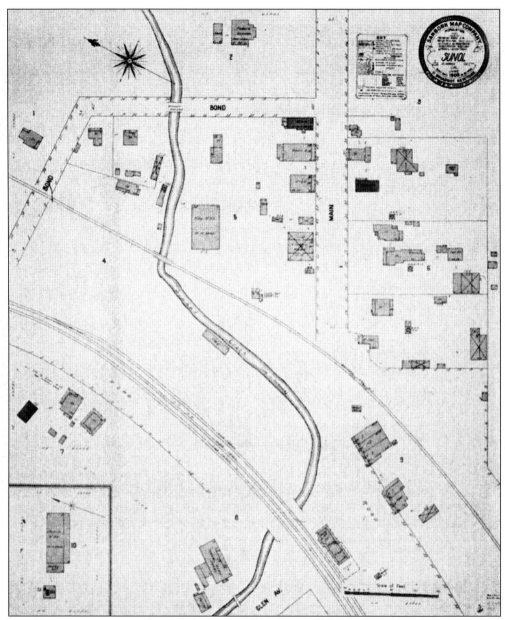

Surveyors Map, 1908. This map shows many buildings and businesses in the downtown area, much more than there is currently. The largest buildings pictured are hay storage warehouses. (Courtesy of Amador–Livermore Valley Historical Society.)

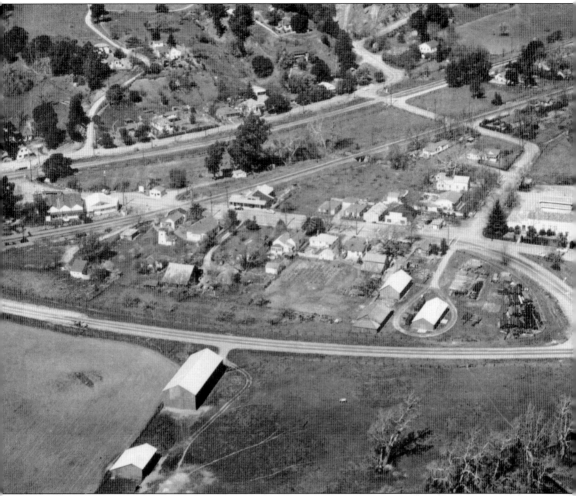

DOWNTOWN AERIAL PHOTOGRAPH. The above image is not dated, but the "new" Sunol Glen School building is clearly visible on the right and the Highway 84 railroad overpass had not yet been built. Therefore, the photograph was most likely captured between 1925 and 1928. (Courtesy of Lori Nielsen.)

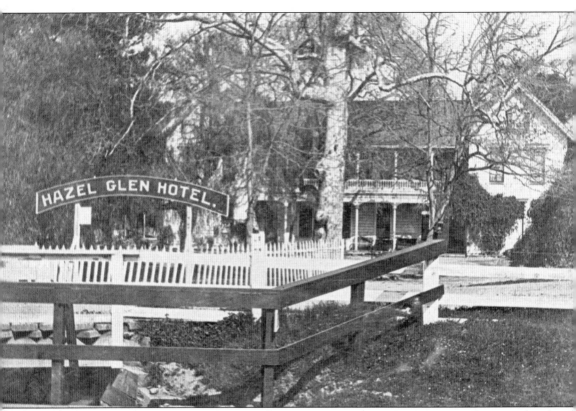

HAZEL GLEN HOTEL, 1906. The Hazel Glen Hotel, located on the corner of Kilkare Road and Foothill Road, was one of four hotels in Sunol. William Hughes and John Andrews were part owners of the Hazel Glen Hotel, which was destroyed by fire on December 5, 1916. The Argente Hotel was located at Scott's Corner; the Del Monte Hotel, known for having the best card room around, was located across from the entrance to the Water Temple; and the Sunol Glen Hotel was located on Main Street near the Western Pacific Depot. (Courtesy of Ario and Joyce Ysit.)

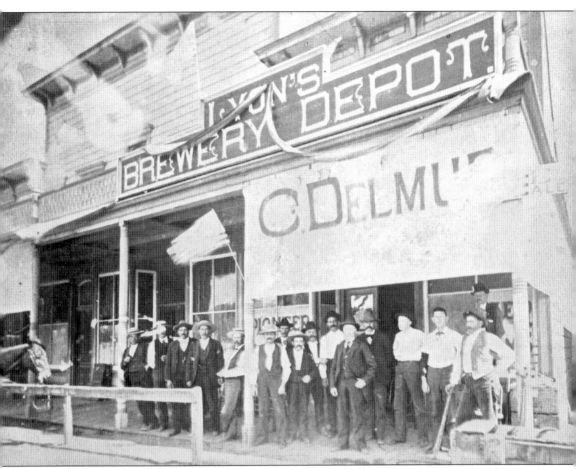

LYON'S BREWERY DEPOT, JULY 4, 1897. In 1867, Charles Lyon began brewing his famous steam beer in a small two-story building in Hayward he called Lyon's Brewery. Lyon later built an establishment in Sunol, calling it the Lyon's Brewery Depot because it was located near the Western Pacific Depot, where kegs of fresh beer were unloaded from the train to be delivered to patrons throughout the Pleasanton and Livermore Valleys. A mere 5¢ could buy a pint of beer; a pail of beer was 10¢. In 1880, the Lyon's Brewery Depot was sold to Leopold Palmtag and Charles A. Hire, who continued to run the thriving business until Congress approved a bill to prohibit the manufacturing and sale of alcohol between 1919 and 1933. During the Prohibition years, they tried to produce non-alcoholic beer, but the concept was unfavorable to their customers. (Courtesy of Amador–Livermore Valley Historical Society.)

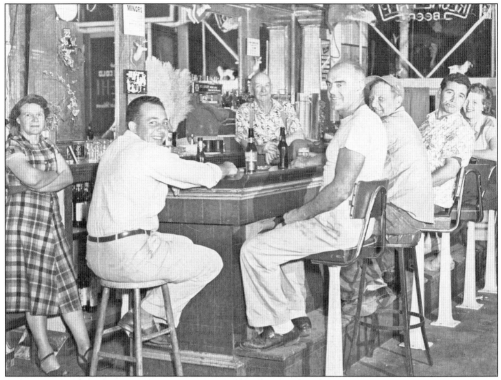

TEMPLE CAFÉ, 1953. The Lyon's Brewery changed hands several times over the years. During the late 1940s and 1950s, Fifi and Henry Aufort purchased the establishment and renamed it the Temple Café. Pictured from left to right are Fifi, Tommy Sparks, Henry (behind the bar), two unidentified, Gilbert Andrade, and unidentified. (Courtesy of Ario and Joyce Ysit.)

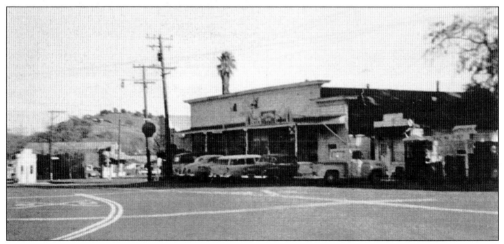

TEMPLE BAR, 1958. Located in the old Lyon's Brewery Building, the business was sold again in the 1960s to Frank and Bertha Rustic. The couple ran a lively, colorful establishment, and Bertha, being a strong-minded businesswoman, booted more than a few patrons from the bar. The first real post office building can be seen on the far left of the photograph. It was replaced with the existing building in 1975. (Courtesy of Ario and Joyce Ysit.)

66

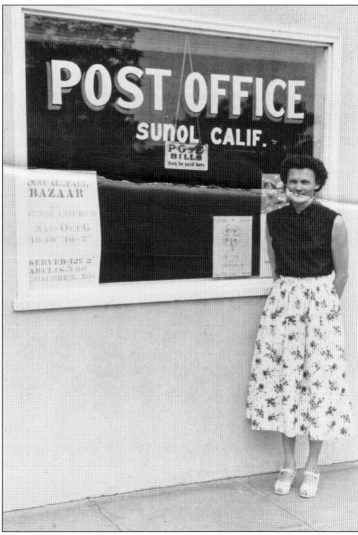

POST OFFICE BOX RECEIPT, 1888. Although the town's postal district covers 100 square miles, the postal service has always been located in the downtown area, just in several different places. The first post office opened on August 11, 1871, and was located in Trimingham's General Merchandise store on Main Street. The payment receipt above was signed by Jose N. Sunol. (Courtesy of Joan Hall.)

SUNOL POST OFFICE. Since 1871, there have only been 11 postmasters—Mark Ager, 1871–1887; Winfield Scott, 1887–1888; Jose N. Sunol, 1888–1889; Lorin J. Ager, 1889–1893 and 1898–1910; George Elemes, 1893–1898; Kate Freeman, 1910–1950; Ralph M. Wright, 1950–1952; Lucille B. O'Laughlin, 1952–1975; Margaret H. Lashway, 1975–1985; and Joan Hall, since 1985. Pictured here is postal clerk Roberta Newberry. (Courtesy of Randy Mills.)

RORABACK HOME. Originally from the Warm Springs area, which is now considered a part of Fremont, in 1925, George Roraback and his wife, Hazel, moved with their two children, Douglas and Betty, to an area located near the Calaveras Dam. In 1926, they moved closer to downtown Sunol. The family moved for the third and final time in 1933 to their home a little farther north on Kilkare Road. (Courtesy of Ario and Joyce Ysit.)

RORABACK'S LETTER TO SUNOL GLEN SCHOOL, JULY 2, 1928. The letter indicates that George Roraback is requesting to make a bid to provide transportation for the school's students at a cost of $7.50 per day. The letter is witnessed by Sunol's first female postmaster, Kate Freeman. (Courtesy of Ario and Joyce Ysit.)

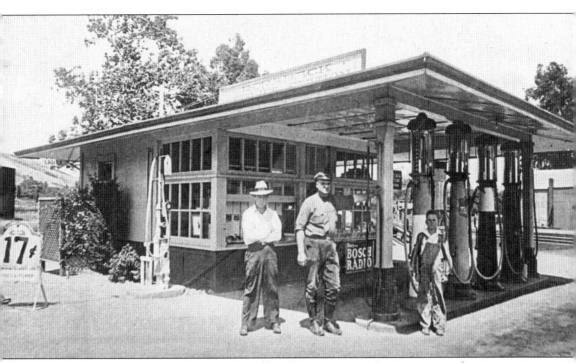

RORABACK'S GAS STATION, 1929. After selling this gas station, George continued to manage it for 13 years before accepting a position with the Alameda County Road Maintenance Department. The gas station was torn down and relocated to the old Mission Pass Road. Pictured from left to right are unidentified, George Roraback, and his son Douglas. Also take note of the advertised price for a gallon of gas—17¢! (Courtesy of Ario and Joyce Ysit.)

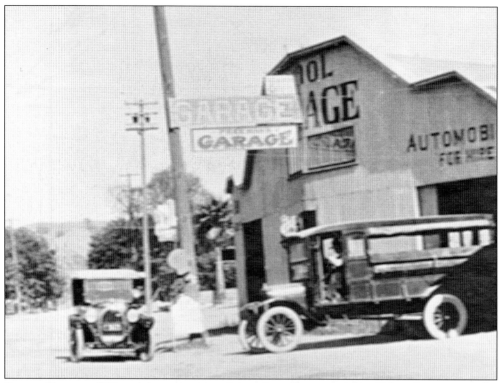

SUNOL GARAGE. This service station was located on the south side of Main Street, near the Lyon's Brewery Depot. (Courtesy of Ario and Joyce Ysit.)

THE OLD CORNER AND THE GENERAL STORE, 1946. Previous maps state that this building had many uses. At some point in time, it was called just a "lunchroom." The Old Corner Store was one of Sunol's many drinking establishments. (Courtesy of Ario and Joyce Ysit.)

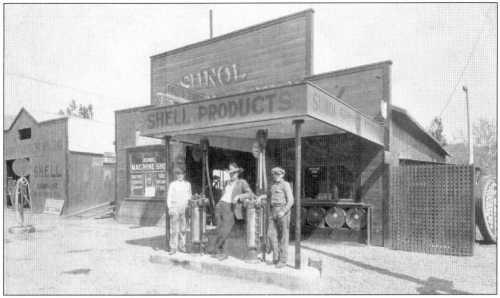

SCHULTZ'S GAS STATION. Located on the corner of Main and Bonds Streets, this station was destroyed by a fire in 1988. (Courtesy of Bill Rebello.)

HUGHES HOME. The great San Francisco earthquake drove the Hughes family across the bay to Sunol, where they built this home in 1907. Besides their Main Street home, the family owned a substantial amount of downtown property, including two smaller cottages located behind the main house and another home that was later converted into a café, Andrews Place. (Courtesy of Miguel Gerardo LaRosa.)

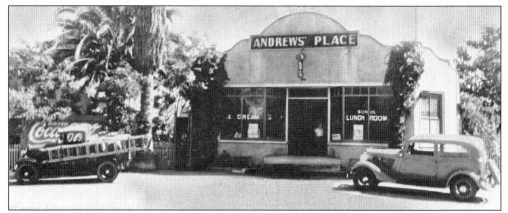

ANDREWS PLACE. Opened by Margaret Andrews and later operated by a Mrs. Murphy, the café/coffee shop/ice-cream parlor/sweetshop originally served as the town's first telephone switchboard. During the 1960s, the business was sold again to two gals named Lil and Charlotte. (Courtesy of Ario and Joyce Ysit.)

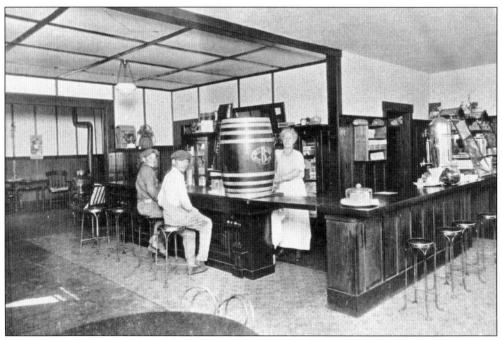

INTERIOR OF ANDREWS PLACE, 1925. Owner Mrs. Murphy is standing behind the counter of this old-fashioned sweetshop in the picture above. She was also the town's switchboard operator, which was located in a tiny room through the door to the right. (Courtesy of Ario and Joyce Ysit.)

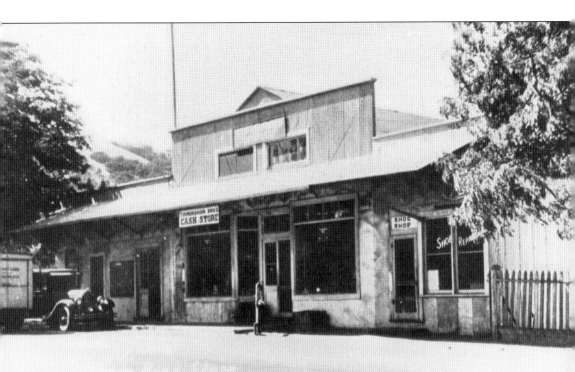

TRIMINGHAM BROTHERS GENERAL MERCHANDISE, 1930–1933. The Triminghams purchased the store, built in 1890, from Robert Ellis in 1900. It was first called J. C. and F. Trimingham Store and managed by John, Charles, and Frank; sisters Effie and Martha were investors. The original store, which sat on the corner of Bond and Main Streets, burned in 1915, and this new store was rebuilt to the west on Main Street. While the new store was being built, a temporary store was established in a shed in the back of the family home across Main Street. Several of the Trimingham grandchildren got their feet wet working in the family store and making deliveries to the work crew at Calaveras Dam. (Courtesy of William Trimingham.)

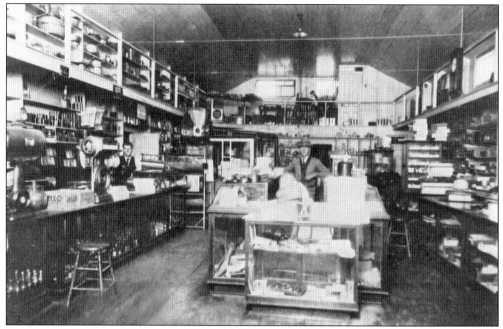

Trimingham's Store Interior, 1930–1933. The general store sold everything from groceries, hardware, shoes, coal, and chicken feed to insurance. The family owned quite a bit of downtown Sunol property, including two houses, the store, and a large barn that housed horses on one side, a car collection on the other, and hay and grain storage in the middle. They had chickens and pigeons, as well as peach, apricot, fig, and walnut trees. (Courtesy of William Trimingham.)

TRIMINGHAM BROS.

GENERAL MERCHANDISE
COUNTRY PRODUCE BOUGHT AND SOLD

SUNOL, CALIFORNIA

AGENTS
ROYAL INSURANCE CO.

After 5 days, return to
TRIMINGHAM BROS.,
SUNOL, Alameda Co., CALIF.

UNITED STATES POSTAGE
2 CENTS 2

Trimingham's Store Stationery. John Trimingham married Alice Chamberlain on October 29, 1907. They raised their five children in a home they rented from John's brother Frank on Main Street. John continued to run the store by himself until his sudden death on December 22, 1940. The store was sold to the O'Laughlin family in 1942. (Courtesy of William Trimingham.)

Six

KILKARE ROAD

Kilkare Road is a three-and-a-half-mile canyon road dotted with homes of different architectural styles, ranging from unique custom homes and historic farmhouses to newer ranch homes and log cabins. Located near the entrance of Kilkare Road is the Apperson house. An English sea captain began building his Queen Anne Victorian-style dream home in 1889 when he died suddenly of tuberculosis. Mark Ager purchased the unfinished home in 1890. A few yards north sits the historic Little Brown Church of Sunol, formerly known as the Congregational Church of Sunol. Built in 1885, the church continues to thrive with an active membership.

After sailing around Cape Horn from the East Coast, Capt. Henry Hiram Ellis arrived in San Francisco in 1848 and later became the city's chief of police. Ellis also ran a successful business shipping provisions from San Francisco to Sacramento to the gold miners. Upon retirement, he purchased property in Sunol and, in 1885, began building his stone mansion known as Elliston. The mansion currently houses Elliston Vineyards.

Another prosperous Kilkare Road landowner was Chicago attorney Thomas Farwell Bachelder. He purchased a total of 2,100 acres of land, which extended over the eastern ridge towards Pleasanton, and built a sprawling ranch that was divided by Sinbad Creek. Bachelder's original ranch home was destroyed by fire, but the carriage house, which was built in 1888, still stands.

Banker Charles H. Crocker purchased land in the far reaches of Kilkare Canyon on May 19, 1926, and turned a profit by subdividing on May 15, 1927. Crocker built 101 log cabins that were originally rented out as summer cabins to wealthy San Franciscans who traveled to Sunol by train and then horse-drawn buggy up Kilkare Road to Kilkare Woods Resort. Crocker's original blueprints show plans that include a pool, playground, ball field, and lodge-style "clubhouse." Those facilities are still in use today.

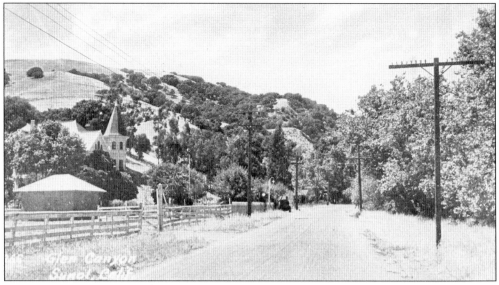

KILKARE ROAD. Once named Hazel Glen Avenue or Glen Avenue, Kilkare Road is the most densely populated of all Sunol byways. Sinbad Creek parallels this beautiful three-and-a-half-mile, dead-end canyon road, bordered by Sunol Ridge to the west and Pleasanton Ridge to the east. Unique and exquisite architectural styles range from ranch-style homes and stately Victorians to rustic log cabins. (Courtesy of Museum of Local History.)

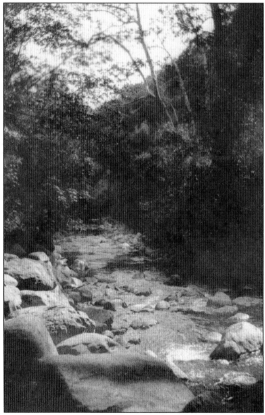

SINBAD CREEK. This seasonal creek once ran continually, and steelhead trout could be seen spawning in its waters. In later years, upper Kilkare Road residents would gather to wager when the creek would begin running. (Courtesy of Rebecca Douglas.)

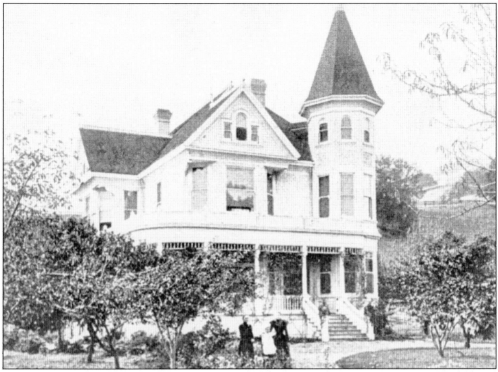

QUEEN ANNE VICTORIAN HOME. Located near the entrance of Kilkare Road is the Apperson house. The unfinished home was purchased by Mark Ager in 1890. Born in New York, Ager moved to Sunol in 1871 and served as the town's first postmaster. (Courtesy of Museum of Local History.)

APPERSON MANSION. After moving from Missouri in 1863 and settling near Santa Clara, Elbert and Elizabeth Apperson purchased their Sunol home in 1899. Elbert's sister, Phoebe Apperson Hearst, William Randolph Hearst's mother, lived in nearby Pleasanton. Elizabeth Apperson sold the home after her husband's death in 1929, and the home has since had several owners. (Courtesy of the Little Brown Church of Sunol.)

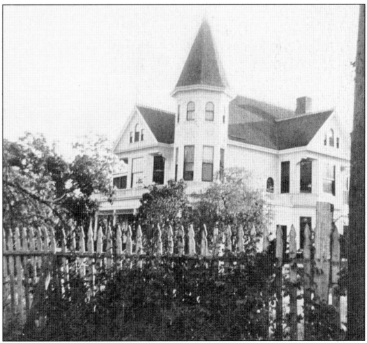

77

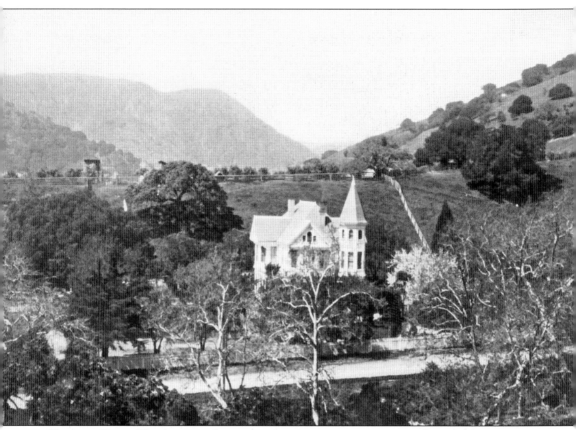

HILLSIDE VIEW. The Apperson home sits on 1.6 acres, is 10,000 square feet, and has 14 rooms, 10 fireplaces, 6 bedrooms, 12-foot ceilings, a wide veranda, formal gardens, and a wisteria arbor. Throughout the years, and the home's many owners, the grounds have changed but the interior remains almost identical. (Courtesy of Candace Newbern and Robert Heath, Day family descendants.)

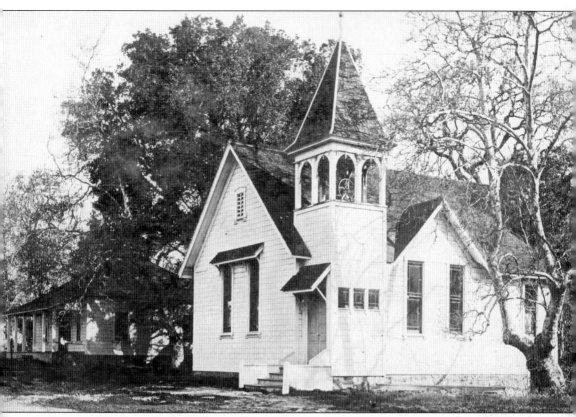

CONGREGATIONAL CHURCH OF SUNOL GLEN, 1910. Worship services were originally held at the Southern Pacific train depot until the Congregationalists began looking for a permanent place to worship. The church filed its Articles of Incorporation in June 1885 as the Congregational Church of Sunol Glen. According to the church clerk's entry dated June 17, 1885, "Plans for the new church building were then presented and accepted with some modification. The main building to be 24 x 41 feet with tower and wing to be not less that 16 x 20 feet with folding doors into main room. The tower to be made higher than shown on the plans." On July 8, 1885, Thomas F. Bachelder deeded a piece of his property between Sinbad Creek and Bachelder Avenue (Kilkare Road) to the Congregational Church of Sunol Glen for $1. (Courtesy of Bill Rebello.)

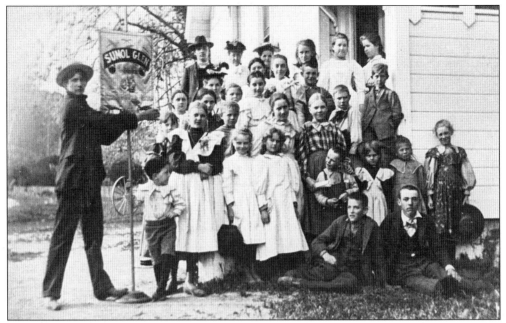

CHURCH YOUTH, 1897. The first services were held in the new church on October 4, 1885, and the new board members included Mark Ager, Capt. Henry Ellis, Thomas F. Bachelder, Charles Hadsell, W. Brown, G. I. Vandervoot, and William Day. (Courtesy of the Little Brown Church of Sunol.)

CHURCH PARSONAGE AND SOCIAL HALL. The church had a strong congregation until 1916, when there was a sharp decline in membership. Even though several laypersons were trying to keep worship services regular every Sunday, the church finally closed its doors in 1923. (Courtesy of Bonnie Bruton.)

CHANGING OF AN ERA. After the end of the war, there was renewed interest in Sunol. Residents were living here year-round and were eager to have a church to call their own. (Courtesy of Bonnie Bruton.)

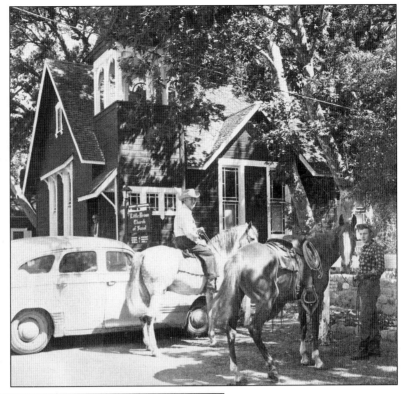

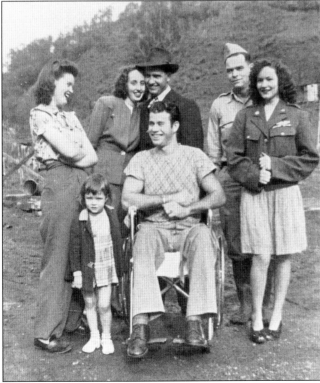

INJURED SOLDIER ARRIVES HOME, 1945. Although he is seriously injured, this family is happy to have their uncle back home in Sunol for the marriage of his brother Richard. Pictured are (first row) Sandy Davis and soldier George McReynolds in the wheelchair; (second row) Norma Davis, newlyweds Delora and Richard McReynolds, Julius Davis, and Wanda Davis. (Courtesy of Ario and Joyce Ysit.)

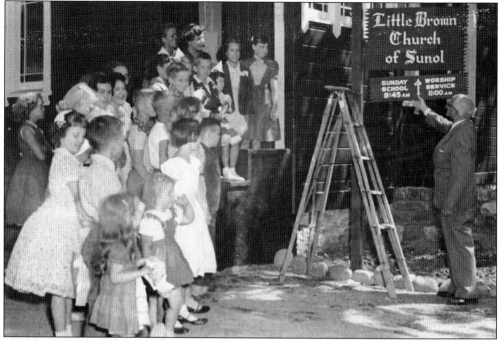

THE LITTLE BROWN CHURCH OF SUNOL, 1954. After 26 years of silence, Rev. Robert Whitaker reactivated the church in 1949, and 30 new members joined on January 22, 1950. During the reverend's tenure, the original buildings were repaired and restored and an extension was added to the social hall. (Courtesy of the Little Brown Church of Sunol.)

ONE HUNDRED–YEAR TIME CAPSULE, 1954. The church was painted brown and renamed the Little Brown Church of Sunol after a popular song and church of the same name in Nashua, Iowa. A rededication ceremony was held on October 10, 1954, and it was during this ceremony that a 100-year time capsule was placed on the church property, not to be opened until October 10, 2054. (Courtesy of Bonnie Bruton.)

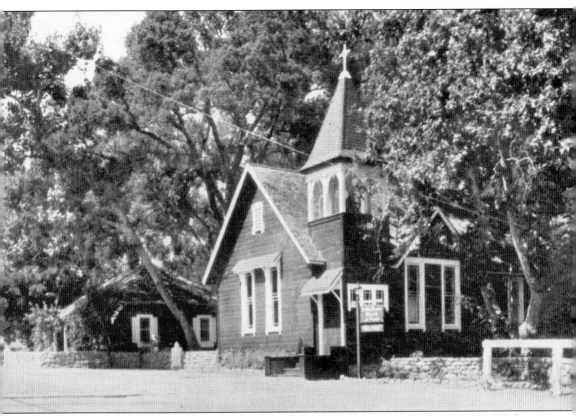

THE LITTLE BROWN CHURCH OF SUNOL, 1960s. The beautiful stone wall that divides the church's courtyard from the street was erected by several women of the church between February 20 and June 18, 1954. The women—Olive Sparks, Barbara Bruton, Louise Gratton, Jackie Lewis, Jean Lawrence, and Ruth Munger—started building the wall from rocks in nearby Sinbad Creek as well as rocks brought in from a ranch near Sunol Regional Park. (Courtesy of the Little Brown Church of Sunol.)

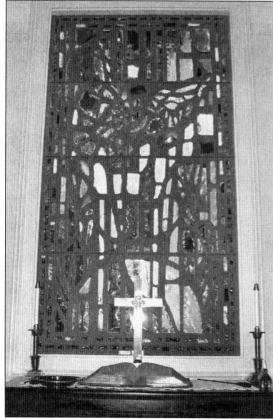

EDNA MCCRACKEN. This stained-glass window depicting a cross and dove with an olive branch, representing "peace through the Holy Spirit, family and community," was installed by the McCracken family in memory of longtime member and Sunday school teacher, Edna McCracken (above). The window was dedicated during the church's 90th anniversary ceremony on October 19, 1975. (Courtesy of the Little Brown Church of Sunol.)

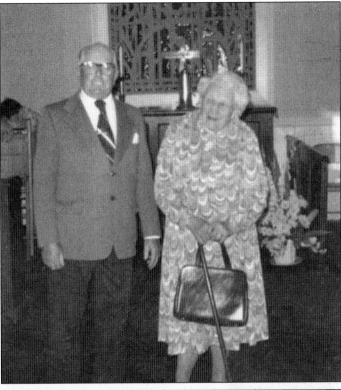

LONGTIME MEMBERS, 1984. Alice Trimingham is pictured here with Sam McCracken. Alice was instrumental in raising funds to purchase the church's bell in 1893. Born on August 21, Alice was attending church this day to celebrate her 100th birthday. Sam McCracken began attending the church at the urging of his wife, Edna, and after her death, he continued to support the church and maintain its lovely roses until his passing. (Courtesy of the Little Brown Church of Sunol.)

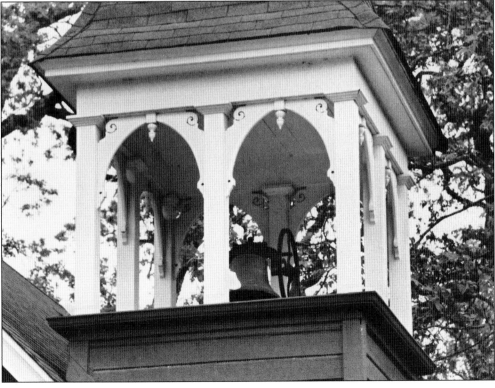

MAY DAY HEATH, 1991. Born on May 18, 1896, May was celebrating her 95th birthday at the church on this Sunday. May's father, William Day, was one of the founders of the Little Brown Church of Sunol. Pictured from left to right are Elizabeth Day Johnson, May Day Heath, Rev. Robert Bench, and Elwood Johnson. (Courtesy of Bonnie Bruton.)

LOWER KILKARE ROAD, 1910. This dusty trail, which twisted through the narrow canyon, was once known as Glen Avenue, Hazel Glen Avenue, and Bachelder Avenue. (Courtesy of Bud Meyers.)

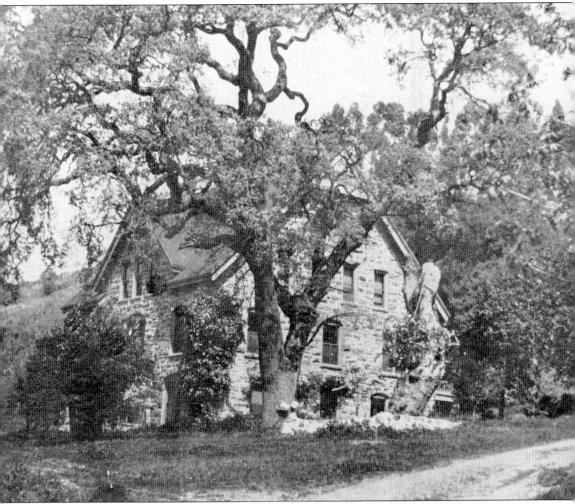

ELLIS MANSION. Upon retirement, Captain Ellis purchased property originally on Calaveras Road, then on Kilkare Road, where he began building the 5,000-square-foot, 3-story, 17-room bluestone mansion known as Elliston. Built in 1885, the mansion is listed on the National Register of Historic Places. (Courtesy of Ario and Joyce Ysit.)

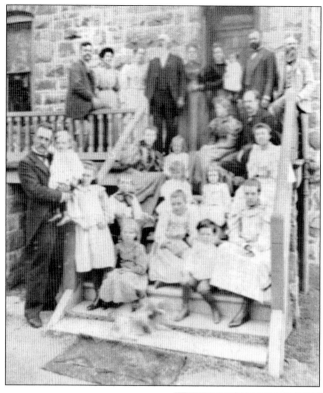

ELLIS FAMILY, 1889. Capt. Henry Hiram Ellis and his wife, Elizabeth, enjoyed receiving visitors, including Prince Kuhio and Princess Elizabeth of Hawaiian royalty in 1898. One of Henry's first successful businesses was to invest in a ship that would bring fresh foods from Hawaii and Mexico. He was also a police chief of San Francisco and later became U.S. Consul of the Turks Island in the East Indies. (Courtesy Ario and Joyce Ysit.)

ROBERT AND GERTRUDE ELLIS, 1958. Both born in San Francisco, Robert (Henry's son) and his wife, Gertrude, continued to live in the mansion until the 1950s, when they moved to another house nearby. Robert attended Vallecitos School and St. Mathews Military School in San Mateo. Gertrude attended Pleasanton Grammar School and San Jose Normal School (San Jose State University), where she earned her teaching degree. She later taught at Rosedale School. (Courtesy of Ario and Joyce Ysit.)

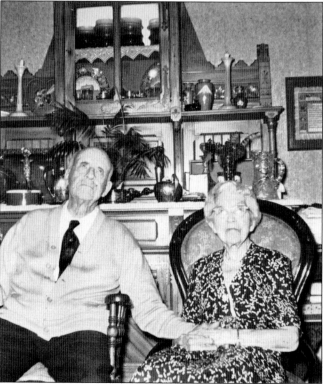

BEAUTIFUL GILDED FIREPLACE. This fireplace is one of three in the Ellis mansion and is located in the sitting room on the first floor. (Courtesy of Miguel Gerardo LaRosa.)

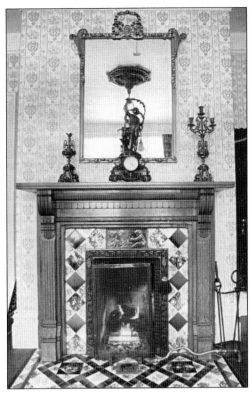

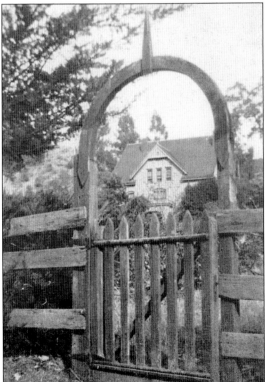

UNIQUE GATE. This garden gate perfectly frames the mansion. In 1890, Captain Ellis planted three acres of vineyards and began producing wine. (Courtesy of Candace Newbern and Robert Heath, Day family descendants.)

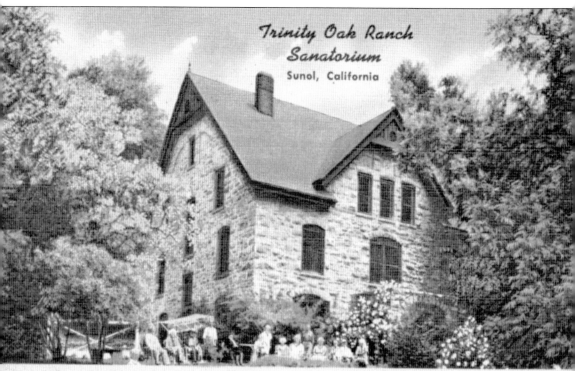

Trinity Oak Ranch Sanatorium

Sunol, California

From Oakland drive South through Hayward; Then via Highway 9 to Niles. Turn Left through Niles Canyon to Sunol. At Sunol drive North on Kilkare Road ½ mile to Trinity Oak Ranch — (On your right).

TRINITY OAK RANCH SANATORIUM, 1947. After several owners, the mansion served as a senior nursing home, pictured in the above postcard. It was reported that during this time, the home's residents would often leave the mansion and could be found wandering in the area. The mansion was later purchased by the Awtry family in 1968 as their private residence. (Courtesy of Elliston Vineyards and Sandi Bohner.)

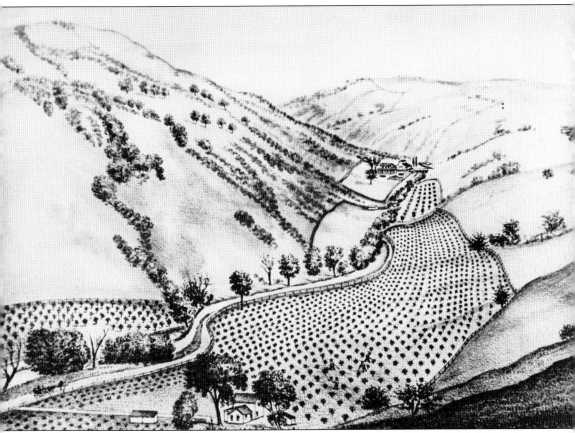

MAP OF BACHELDER RANCH, 1878. This map shows Thomas F. Bachelder's sprawling ranch that was divided by Sinbad Creek. He purchased his land from the Sunol-Bernal families and planted grape vineyards, olive trees, and several other types of crops. Homes are now built where the orchards once stood. (Courtesy of *Thompson and West Atlas*.)

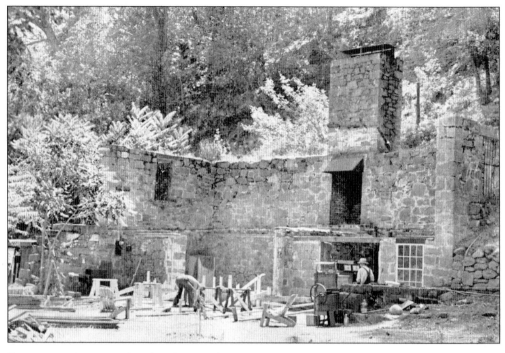

BACHELDER HOME. After fire destroyed the home, all that remained was the rockwork that was once the home's side and rear wall. The land was then purchased in the 1940s and a new home built around the existing rock structure. The photograph below shows the home's original fireplace. (Courtesy of Pam Peeters.)

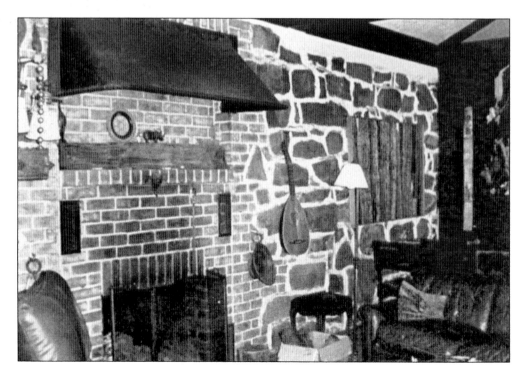

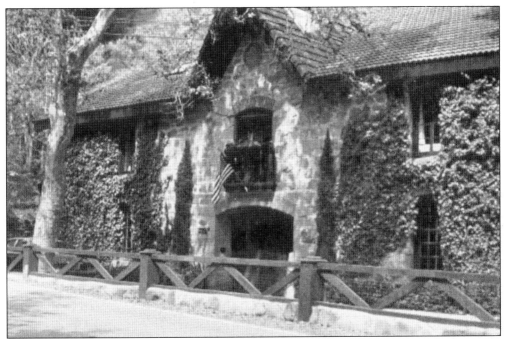

BACHELDER BARN. The ranch also included stables and this stone carriage house, built in 1888 with rock quarried from nearby Sinbad Creek. The carriage house, now known as Bachelder Barn, is listed with the National Register of Historic Places. (Courtesy of Ario and Joyce Ysit.)

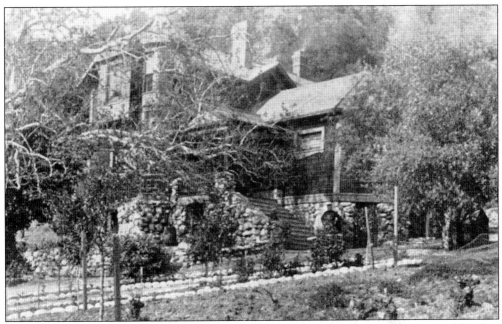

WIEKING HOME. Anita Wieking had the distinction of teaching two generations of families and holds the record for number of years associated with Sunol Glen School. She began as a schoolteacher when the new school opened in 1925 and was principal by the time she retired in 1963. (Courtesy of Bud Meyers.)

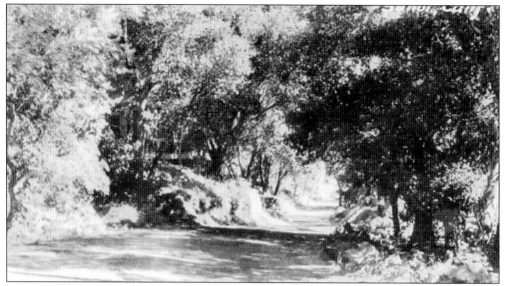

UPPER KILKARE ROAD, 1912. Thomas Bachelder would provide horse-and-buggy transportation up Kilkare Road for visitors arriving by train. The road was widened and paved after Crocker purchased his property at the other end of the narrow canyon. (Courtesy of Bud Meyers.)

KILKARE WOODS HOMEOWNERS SIGN. By 1940, most of the cabins were occupied year-round, and the Kilkare Woods Homeowners Association purchased all remaining properties in July 1943. (Courtesy of Jessica Christian.)

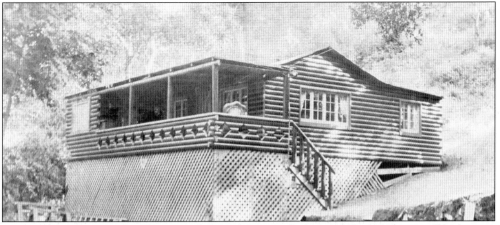

LOG CABIN. An original Kilkare Woods log cabin typically contained one or two small bedrooms, one bath, and a great room surrounded by plenty of windows and a front porch. Over the years, most homes were remodeled and enlarged but have managed to keep their same unique half-log style. (Courtesy of Bill Rebello.)

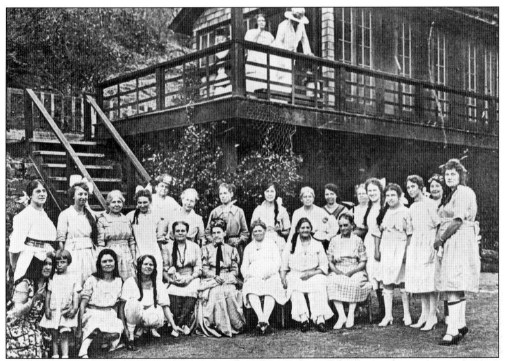

COMMUNITY HOUSE, EARLY 1920s. Charles Crocker's original blueprints show a building that was to be used for a variety of functions and gatherings. The building was originally a home and was known as the Jacobus Cottage. It was later remodeled, and the wide porch was enclosed to create one large room. Now called the Kilkare Woods Clubhouse, it is currently serving the homeowners. (Courtesy of Museum of Local History.)

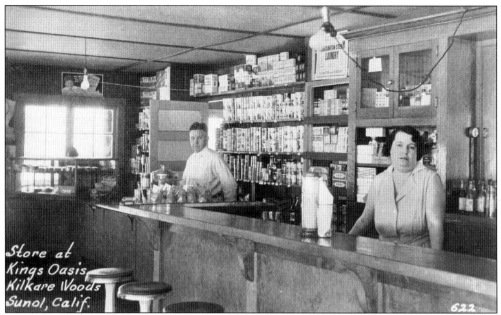

KING'S OASIS STORE, EARLY 1940S. This small store, located in Kilkare Woods on Glenora Way, sold everything from sandwiches, ice cream, and dry goods to beer. Lee and Alice King, pictured here, sold the store in the mid-1940s and purchased the Bachelder Barn with an idea to turn the building into a restaurant. However, that plan was aborted. The store was remodeled into a residence in the early 1990s. (Courtesy of Bill Rebello.)

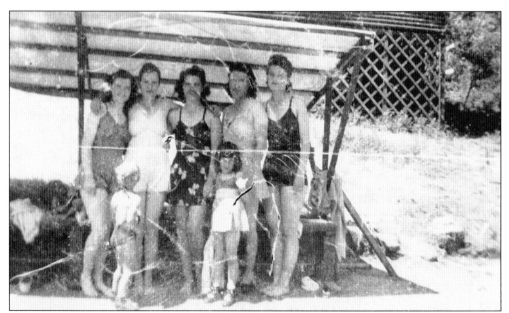

KILKARE WOODS POOL, 1942. The "members only" Kilkare Woods community pool is located below the clubhouse, which is visible in the background. Pictured from left to right are Norma Davis, Frances Davis, Lorena Mills, Sylvia Davis, Jo Davis, June Davis, and Joyce Davis. (Courtesy of Ario and Joyce Ysit.)

Seven

OLD-FASHIONED FUN

The Alameda Creek, which flows alongside Niles Canyon Road, was originally diverted to the area's crops. When Charles Hadsell bought Antonio Sunol's property in 1862, he built a dam and called his popular campground Hadsells Big Springs. After the railroad was established, amusement parks and campgrounds such as Sim's Place, Fern Brook, Joyland, Stonybrook, Brightside, Jay's Park, and Idlewild sprang up all along the creekside. When Spring Valley Water Company arrived, they also diverted water that would be piped to San Francisco.

Bands were very popular at the campsite and picnic areas lining Niles Canyon Road. But once residents started building in the area, their homes would be flooded by the creek, which turns into a fast-moving river during the rainy winter months. The Army Corps of Engineers aligned the creek and stabilized its banks, building several small concrete dams to further contain it.

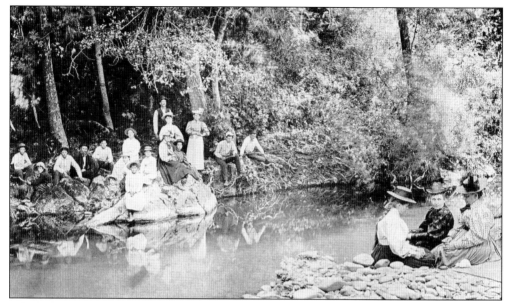

A Day in the Country. The cool waters of Alameda Creek, which runs through nearby Niles Canyon, were inviting to the city dwellers arriving by train. In fact, it was just those visitors who chose to build their summer homes and then permanently live in Sunol. (Courtesy of Museum of Local History.)

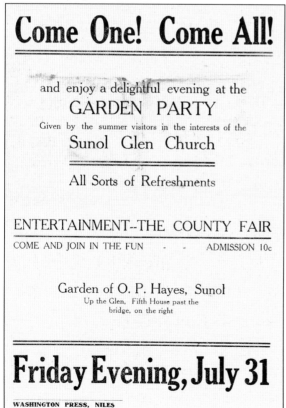

GARDEN PARTY. This poster announces a magnificent party, one of several fund-raisers that were held to help build the church's sanctuary in 1885 and the parsonage in 1907. (Courtesy of Joan Hall.)

THE SUNOL SENTINEL, 1887. Locals were thrilled to have their very own newspaper, published by C. L. Frank and Company. Unfortunately, the newspaper was cancelled after only 10 issues. The advertisements indicate quite a variety of services available to consumers in Sunol, probably more than can be found now. The Hub sold imported cigars, Ellis and Sanborn sold clothing, and the Cosmopolitan Hotel offered French meals. (Courtesy of Ario and Joyce Ysit.)

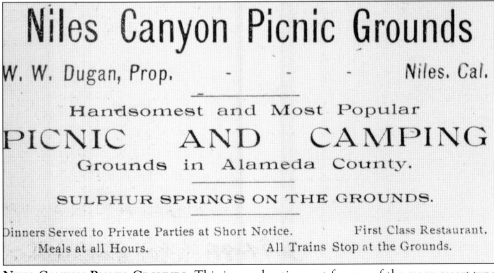

NILES CANYON PICNIC GROUNDS. This is an advertisement for one of the many resort-type facilities that lined nearby Niles Canyon. (Courtesy of Museum of Local History.)

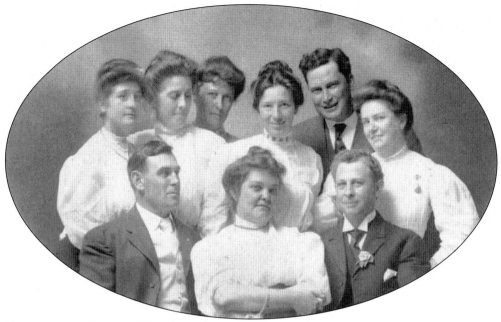

GATHERING OF FRIENDS. This classical portrait is a comical look at a group of friends obviously having fun posing for the photographer. Grace Elliott is pictured directly behind the women in front with her arms crossed. One can only wonder what the young woman is thinking. Note their fashionable attire and chic hairstyles. (Courtesy of Kathleen Elliott.)

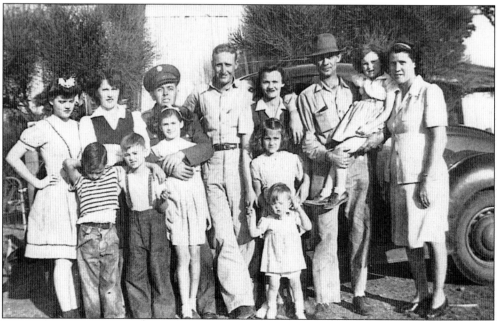

MILLS AND DAVIS FAMILIES, 1940S. Members of this large, extended Sunol family enjoyed making homemade ice cream at family gatherings. Pictured from left to right are (first row) Larry Newberry, Donnie Mills, Glenda Mills, Dolores Newberry, and Sandy Davis; (second row) Norma Davis, Lorena Mills, Orbin ?, Art Newberry, Roberta Newberry, Thurman Mills, Joyce Davis, and Sylvia Davis. (Courtesy of Ario and Joyce Ysit.)

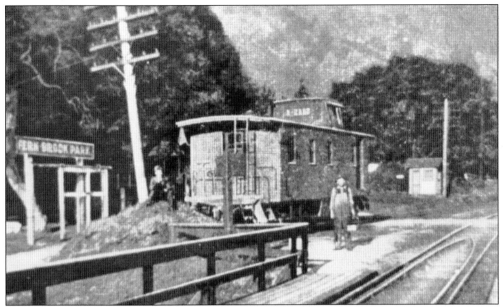

FERN BROOK PARK ENTRANCE. Passengers brought their own picnic lunch, and the park sold ice cream. Campgrounds were later established to accommodate city folks who chose to stay overnight. (Courtesy of Phil Homes.)

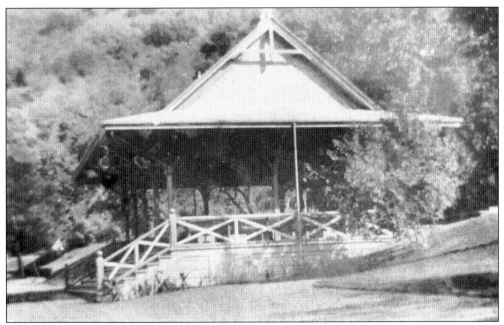

DANCE PAVILION. When the train arrived at the Farwell train stop in Niles Canyon, John Philip Sousa and 40 members of his orchestra were on hand to play for the disembarking passengers. The band continued playing at this large wooden dance pavilion, located at the Fern Brook Picnic Grounds. (Courtesy of Amador–Livermore Valley Historical Society.)

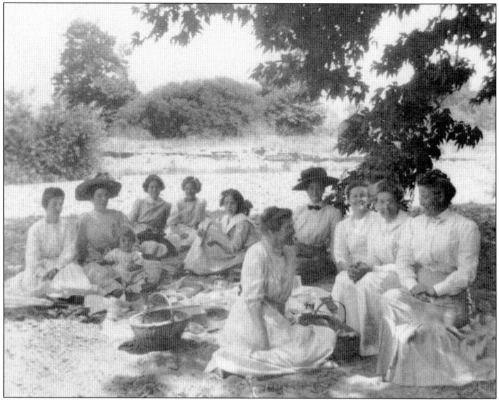

PICNIC AT THE TEMPLE AND ON BUTTNERS PEAK, 1907. The ladies and gentleman pictured are all very formally dressed for a day in the country but appropriate for the era. The mild climate and beautiful surrounding provided a perfect spot for an afternoon picnic. (Above, courtesy of Rebecca Douglas; below, courtesy of Bill Rebello.)

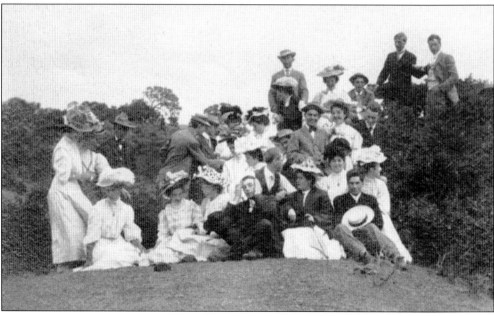

HORSEBACK RIDING, 1912. These ladies are pictured taking a leisurely ride on Kilkare Road near the Hayes Home. The woman above is Sunol Glen School teacher Eunice Reaper; the woman below is Gladys Hayes. (Courtesy of Joan Hall.)

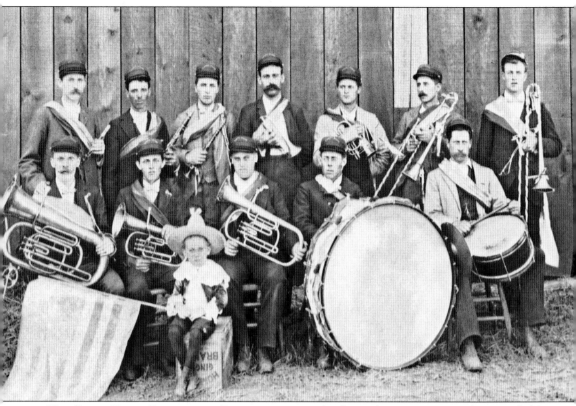

THE SUNOL BAND, LATE 1890S. Dances were a popular form of entertainment. They were held regularly at several locations in town, such as the Water Temple and at the Fern Brook Park bandstand in Niles Canyon. Pictured from left to right are (first row) Charley Trimingham, Frank Crane, unidentified boy with a flag, Louis Malarat, Edward Vandervoort, and unidentified; (second row) George Trimingham, unidentified, Frank Trimingham, Tony Silver, John Trimingham, Will Vandervoort, and unidentified. (Courtesy of William Trimingham.)

UPPER KILKARE ROAD SNOW, 1957. Although it's rare, it does snow in Sunol's higher elevations, as seen in this photograph. The young boy facing the camera is Randy Mills. (Courtesy of Glenda Beratlis.)

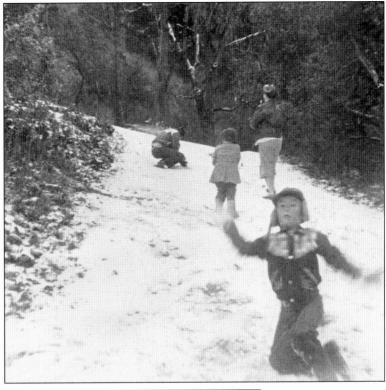

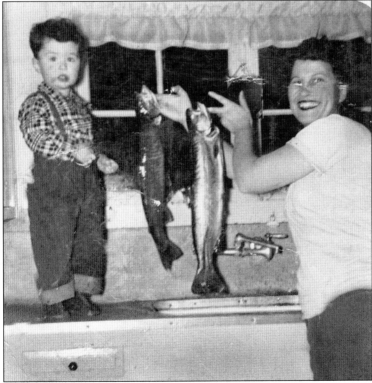

SINBAD CREEK STEELHEAD TROUT, 1953. Amazing as it seems, because the shallow creek is now only seasonal, these fish were caught in Sinbad Creek, which runs the length of Kilkare Road. The creek used to run continually all year long, but unfortunately, because of a variety of bureaucratic issues, the fish no longer spawn in the creek. Pictured are Randy Mills and his mother, Lorena Mills. (Courtesy of Randy Mills.)

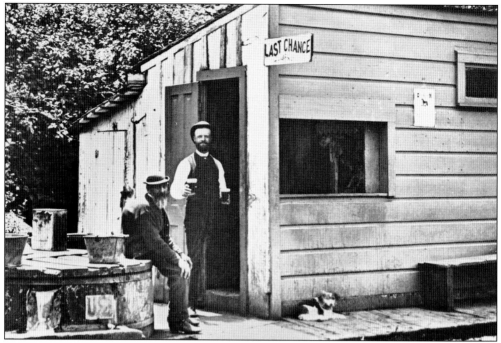

LAST CHANCE SALOON. Located in Niles Canyon at Sim's Park, this local drinking establishment was one of several in the area. (Courtesy of Amador–Livermore Valley Historical Society.)

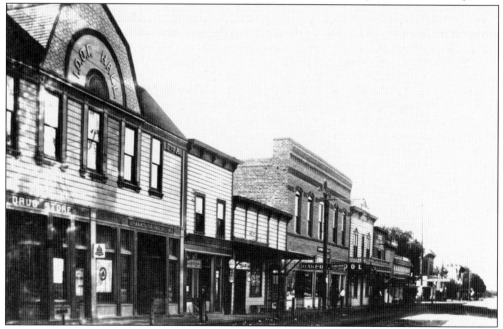

DOWNTOWN NILES, 1908. Sunol and the quaint community of Niles have always had a special relationship as neighboring towns even though they are divided by the 5-mile-long Niles Canyon Road; Sunol sits at the east entrance of the canyon and Niles at the west. The road, which was paved in 1928, was another option of traveling west without going over Mission Pass. (Courtesy of Museum of Local History.)

Eight

Sunol in the 21st Century

Sunol continues to provide a unique lifestyle for residents looking for a relaxed, slow-paced, country environment free of big-city crime. Yet the continued threat of annexation from neighboring cities and further development has kept residents of this tiny hamlet on their toes for decades.

In 1983, a local rancher requested and received approval from the Alameda County Supervisors to build a large residential development of 83 custom homes on 440 acres of Sunol's pristine eastern ridgetop. Sunol residents said "no way" and launched the "Save the Ridge" referendum signature drive campaign, collecting 15,000 more signatures than the required 40,000 within 30 days. The county supervisors rescinded, and the ridgelands were saved from future development and acquired by the East Bay Regional Park District for all to enjoy.

Members of the nonprofit local grassroots community group Save Our Sunol more recently waged their own battle against Alameda County when, in 1995, officials approved a request from a gravel quarry mining company to expand their operations from the southeast side of Highway 680 on land owned by the City of San Francisco and adjacent to the Water Temple. Residents and environmental groups combined forces to try to prevent the destruction of 242 acres of land that has always been used for agriculture because of its rich, fertile soil. Unfortunately, their attempts to stop the quarry were unsuccessful, and San Francisco city officials approved the mining operation, which began in 2006.

Although the town had succumbed to a rash of accidental and suspicious fires on Main Street during the 1980s, residents proved resilient, and a community effort was launched to, ironically, improve the downtown water system and install more fire hydrants. During the 1990s, local businesses formed the Sunol Business Guild, and they began holding fund-raisers to beautify the downtown area; a community park was established. More recently, in 2006, residents again fought and won a battle to prevent a large green waste facility from being built near Andrade Road.

MAYOR BOSCO, 1983. A black Labrador mix, Boss "Bosco" Ramos was born in November 1979 and was owned by Brad Leber and later Tom Stillman. In August 1981, patrons of a local drinking establishment decided that Sunol, being unincorporated, needed a mayor. An impromptu election was held between Bosco and two human rivals, Paul Zeiss and a man named Wolf. With a campaign slogan of "Dogs are people too," and promising "a bone in every dish, a cat in every tree and a fire hydrant on every corner," the 85-pound lab mix scored a major victory, receiving 75 of 120 votes. After being featured in *Star* magazine on July 24, 1984, Bosco received international media coverage from Germany, France, and China. On February 23, 1990, a leading newspaper in China, the *People's Daily of Beijing*, picked up the story, stating that this proves that "American democracy is going to the dogs." The newspaper story continued, "Western 'democracy' has reached such a peak of perfection that not only can one talk of democracy between people, but democracy between dogs and people. There is no distinction between people and dogs," and the election "can be seen as a wakeup tonic for those kind-hearted people who are naïve and ignorant and blindly worship Western democracy." Local folks thought it sad that the Chinese government would take the election so seriously. In response to the outrageous statements made by the Chinese government, in 1991, Bosco attended a human-rights protest at the Peoples Republic of China consulate in San Francisco. Bosco was present at all community events and served as the town's grand marshal in the annual pet parade; he also appeared on several national news programs and was featured in several popular magazines. Bosco, who died in July 1994, is buried in an undisclosed location in Sunol. (Courtesy of Ario and Joyce Ysit.)

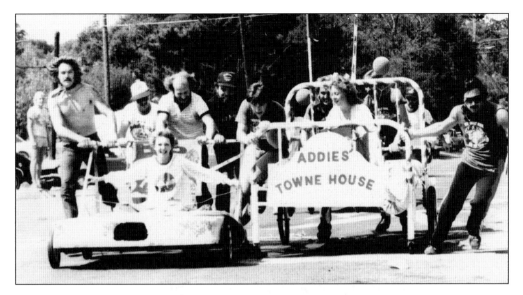

THE GREAT SUNOL BED RACES, 1982. A good-natured rivalry between two saloons, the Lyon's Brewery Depot and the Sunol Lounge, turned into a street race of an unconventional kind. Originally held on Main Street, this race turned into an annual event as more community groups entered for cash, trophy, and bragging rights. After many years without a bed race, the Sunol Business Guild decided to hold the Great Sunol Bed Race and Chili Cook-off, with proceeds going to different nonprofit groups in town. In recent years, the Save Our Sunol group has also held an annual Sunol Country Celebration, which included a silent and live auction, wine tasting, music, and food. (Courtesy of Ario and Joyce Ysit.)

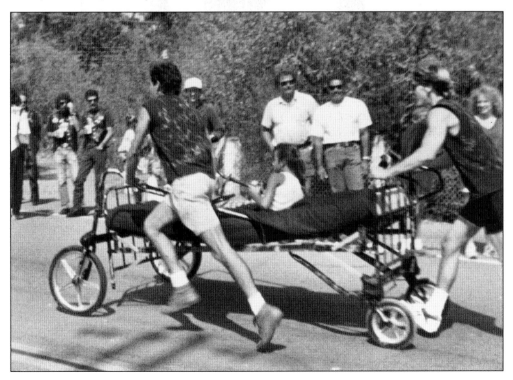

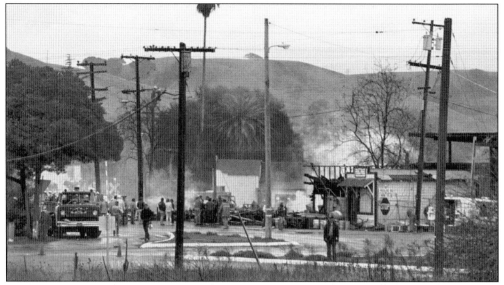

LYON'S BREWERY DEPOT BUILDING, 1987. Built in 1862, Sunol's largest downtown structure burned to the ground at 3:35 a.m. on December 22. The 6,000-square-foot building housed a variety of businesses over the years, but it was the old-fashioned saloon that was made famous by two celebrities; Charlie Chaplain supposedly filmed part of one of his movies in the establishment and singer Willie Nelson serenaded bar patrons. After several owners, Frank and Jan Louthan bought the vacant building in 1980 and restored the old saloon. The business was sold for a final time in 1983 and was operating under the original name of Lyon's Brewery Depot when it was destroyed. It is believed that a faulty gas line in the adjoining hay and feed store caused the devastating fire that spread though the building. The picture above, captured at dawn's first light on the morning of the fire, shows the smoldering destruction. Below, this photograph shows the building four years prior during the second annual bed races. (Courtesy of Ario and Joyce Ysit.)

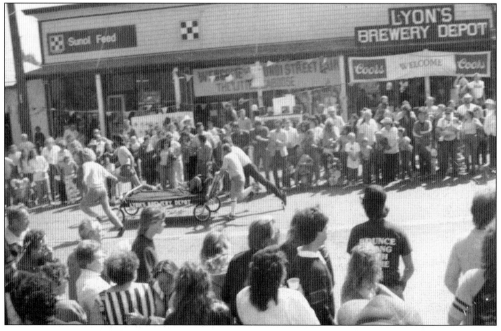

TRIMINGHAM HOME BURNS, 1988. Located on Main Street, this was where the Trimingham family gathered from 1891 until the home was sold in 1942. The family also built the adjacent home seen to the left of the burned structure and in the photograph below. The adjacent home is still standing today. (Courtesy of Ario and Joyce Ysit.)

SUNOL SERVICE STATION. The book's cover photograph was supposedly the oldest continuously operating gas station in Alameda County and possibly the oldest in the state of California. Built in 1919, the gas station and body shop was destroyed by fire on the evening of May 7, 1989. The photograph shows the vacant lot where the station once stood at the corner of Main and Bond Streets. (Courtesy of Miguel Gerardo LaRosa.)

BETTY RORABACK. At 88 years old, Betty has lived in Sunol almost her entire life. Born in San Jose on September 20, 1918, she attended Sunol Glen School and Washington High School in Fremont. After attending the University of California, Berkeley, she attended Heald Business School. (Courtesy of Betty Roraback.)

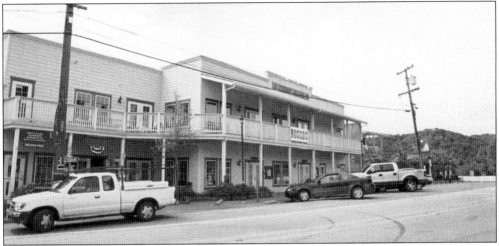

CERNEY BUILDING. The land where the Lyon's Brewery Depot building burned stood vacant for several years until Mike and Joan Cerney bought the property and constructed this new building, which was designed to look exactly like the original. The only difference is that the original building had the old western look of a false second-story facade and the new building actually has a second level. (Courtesy of Miguel Gerardo LaRosa.)

BOSCO BEER. Only in Sunol would one find a life-sized replica of its mayor sitting atop a saloon counter in a restaurant named Bosco's Bones and Brew. Commissioned by former restaurant owners Mike and Joan Cerney, the mechanical dog is actually a beer tap. Just lift Bosco's tail, position your glass in just the right spot, and voilá, a nice cold beer. (Courtesy of Bosco's Bones and Brew.)

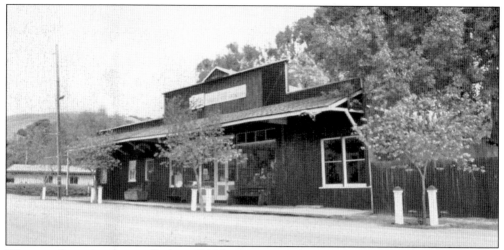

WHISTLE STOP ANTIQUES. Built in 1915 by the Trimingham family, this building once housed several families and was considered Sunol's first and only apartment house. In recent years, it has been a wonderful old co-op antiques shop. (Courtesy of Miguel Gerardo LaRosa.)

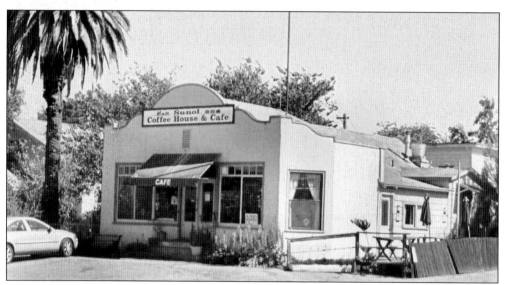

SUNOL COFFEE HOUSE. Once called Andrews Place, this establishment has always been the hub of social gatherings. In recent years, the small café has also been called Addie's, Kathy's, and Bobbie Jo's. (Courtesy of Miguel Gerardo LaRosa.)

COMMUNITY PARK DEDICATION. Established in 1994, the Pacific Locomotive Association originally leased the park property from Alameda County, and the Sunol Business Guild dutifully maintained its appearance until September 2006. The guild is also responsible for the planting of the tall cedar tree in the park in October 1995 and for starting a community tradition of an annual Christmas tree-lighting ceremony on the first Saturday of every December. (Courtesy of Ario and Joyce Ysit.)

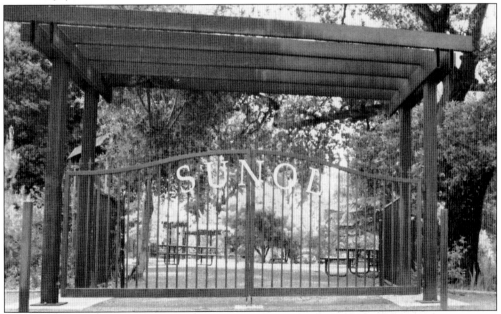

NEW PARK GATE. The park is now maintained and operated by an agreement between the Pacific Locomotive Association and a new volunteer community group, Friends of the Park. Built in 2006 by local volunteers, this iron gate welcomes visitors to the park, which is located near the center of town and bordered by Kilkare Road, Main Street, and Bond Street. The Friends of the Park group has made several improvements to the park, including erecting a new fence. (Courtesy of Miguel Gerardo LaRosa.)

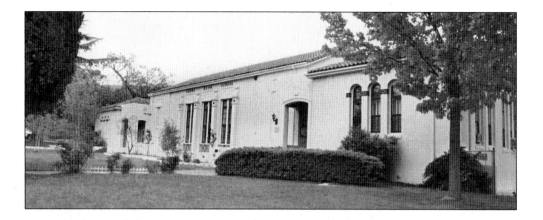

SUNOL GLEN SCHOOL. Built in 1925, the school has recently been renovated and additional buildings added to form a central courtyard. The school is known for its small class sizes, small-town charm, and academic excellence. Sunol Glen's popularity shows in its numbers; nearly 71 percent of the approximately 200 students are transfers from nearby cities. (Above, courtesy of Miguel Gerardo LaRosa; below, courtesy of Sunol Glen School.)

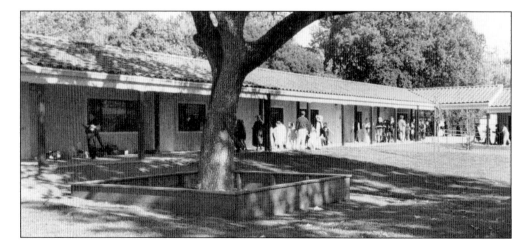

Sunol Town Hall and Event Center. Built in the 1960s, this newly remodeled building once housed a small general store and lounge. The complex now offers residents a place to gather. (Courtesy of Miguel Gerardo LaRosa.)

COMMUNITY BULLETIN BOARD.
Founded in 1993, the Sunol Business
Guild has raised funds to beautify the
downtown area. The group provided
funds to build a community bulletin
board, wooden signs that say "Welcome
to Sunol" located at the east and west
entrances from Highway 84, white
picket fencing, and this ornate town
clock, which is located on Main Street.
(Courtesy of Miguel Gerardo LaRosa.)

Take a trip back in time... on the route of the
First Transcontinental Railroad

THE NILES CANYON
HERITAGE RAILWAY

A railroad museum where the exhibits come to life;
built and operated by the volunteers of the
Pacific Locomotive Association, Inc., on the
original route of the first

TRANSCONTINENTAL
RAILROAD

PACIFIC LOCOMOTIVE ASSOCIATION.
The train right-of-way was taken over by
Alameda County and a volunteer group of
train enthusiasts, the Pacific Locomotive
Association, who contracted with the
county to run their vintage train collection.
In 1988, the group had successfully re-laid
track and were running their trains on a
one-mile trip into Niles Canyon. The Pacific
Locomotive Association has become quite
popular, attracting thousands of passengers
and continuing to provide train rides on their
historic rolling museum. (Courtesy of the
Pacific Locomotive Association.)

SUNOL DEPOT RETURNS, NOVEMBER 1998. After years of neglect, Alameda County acquired the abandoned depot that had been moved one mile west along Alameda Creek. But with combined efforts by the Pacific Locomotive Association, local politicians, and many volunteers, the building was moved back into town and now sits very near to its original location. (Courtesy of Ario and Joyce Ysit.)

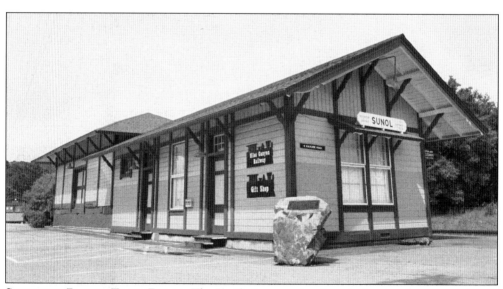

SOUTHERN PACIFIC TRAIN DEPOT. The Pacific Locomotive Association continues to maintain this beautifully restored depot and offers the facility as a meeting place for several of Sunol's nonprofit groups. (Courtesy of Miguel Gerardo LaRosa.)

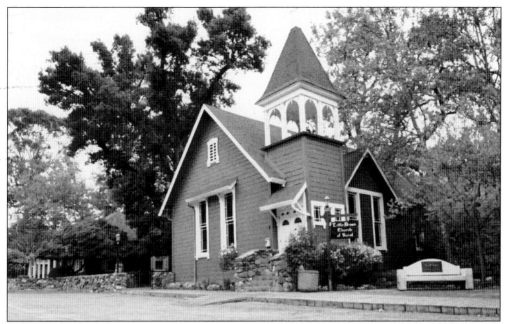

THE LITTLE BROWN CHURCH OF SUNOL. It has been widely rumored over the years that silent movie star Mary Pickford filmed two movies at the Little Brown Church of Sunol, but that fact has never been proven. (Courtesy of Miguel Gerardo LaRosa.)

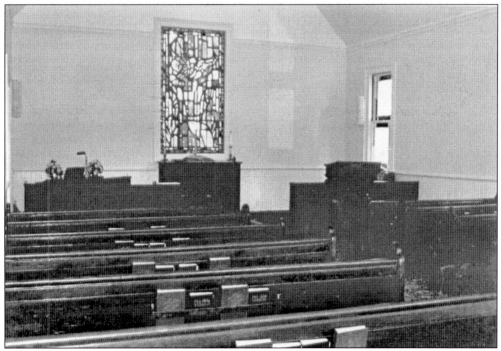

CHURCH INTERIOR. The church continues to thrive in this small community. Its country charm and Victorian interior make it a popular wedding site. (Courtesy of Jessica Christian.)

Town Attracts Moviemaking. California's first "Hollywood" was Essanay Studios in nearby Niles. Silent films, such as *The Tramp* starring Charlie Chaplin, were filmed in Niles Canyon. Several independent films and one made-for-television movie starring Craig T. Nelson and Kirk Douglas was filmed on Main Street in Sunol. (Courtesy of John Beard.)

Sunol Provides a Unique Location. In May 2006, a full-length feature film called *The Confessional* was filmed in town. The psycho-thriller, directed by James Anthony Cotton and produced by Martha Holder, was filmed at several locations, and local townspeople had the opportunity to appear as extras in the film, which is slated for release in mid-2007. (Courtesy of John Beard.)

SUNOL REPERTORY THEATRE.

~ PROUDLY PRESENTS ~

OUR 25TH SEASON, 2006 PRODUCTION

Caught in the Villain's Grasp

or...

Your Mother Was Right about Those Theatre People

An Olde Tyme Melodrama

Written and Directed by E. Thomas Harland

Evenings at 8 p.m.

MARCH 4, 10, 11, 17, 18, 24 & 25

Sunol Glen School Theatre
Sunol, California

Proceeds Benefit Sunol Glen School

SUNOL REPERTORY THEATRE. Founded in 1982 by Tom and Vicki Harland, the Sunol Repertory Theatre is a group of volunteers who performs a melodrama every year during the month of March. The Harlands wanted to create an opportunity to raise funds for Sunol Glen School's educational art department. Over the last 26 years, the theater group has donated almost $90,000 to the school. (Courtesy of Ario and Joyce Ysit.)

SUNOL REPERTORY THEATRE. Audience participation is common with Old West melodrama plays, and patrons are encouraged to yell and cheer for the good guys and boo and hiss the villains. Pictured above are several cast members from the theater troupe's 25th season. Pictured below are actors Stephan Doyle (left) and Derek Johnson disguised as women hairdressers. (Above, courtesy of John Beard; below, courtesy of Sunol Repertory Theatre.)

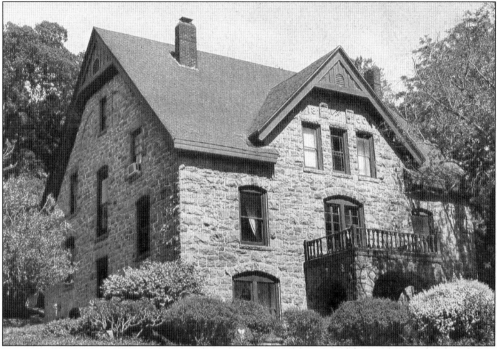

ELLISTON VINEYARDS. The Awtry family purchased the beautiful Ellis mansion in 1968 and after considerable restoration decided to try their hand at winemaking. Their daughter, Donna Awtry, currently at the helm of this successful winery, has transformed the mansion and grounds into a popular wine-tasting venue. Also on the property is a large banquet room and outdoor garden wedding facilities. (Courtesy of Jeff Ysit.)

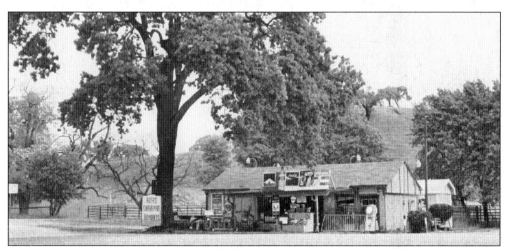

SUNOL CORNERS STORE. Once the site of Sunol's most famous card room, which was located in the Del Monte Hotel, this establishment provides refreshments to weary commuters who pass by their Highway 84 location. (Courtesy of Miguel Gerardo LaRosa.)

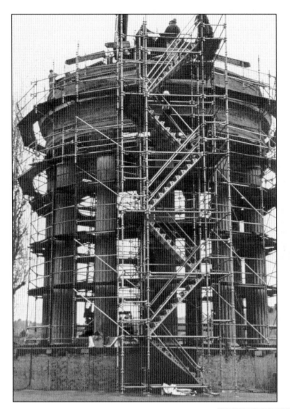

WATER TEMPLE RESTORATION AND PRESERVATION. To encourage the San Francisco Public Utilities Commission to restore the crumbling site, a campaign was started by a local community group, Save Our Sunol. Approval was won in 1996, and a celebration was held on September 27, 1997, to announce the beginning of the restoration project. The roof was removed and careful restoration began at the Oakland Museum's warehouse. Considering the age of the temple, it also received an earthquake retrofit. The temple's main roof beams were placed back on the building on March 27, 2000. (Courtesy of Cindy Frillman.)

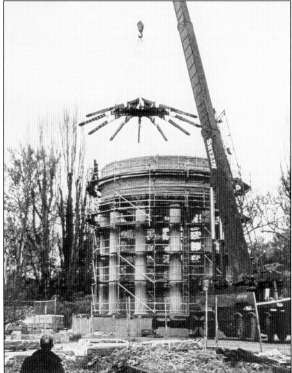

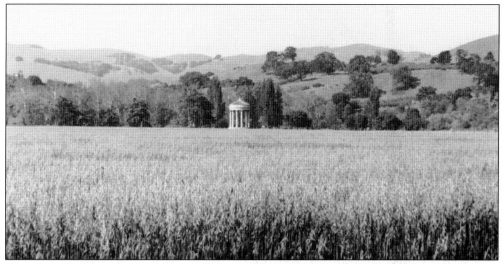

BEAUTIFUL PASTURELAND. After nearly three years of restoration, over 400 community members and local leaders gathered at a rededication ceremony held on September 9, 2000. The restoration project received the 2001 Preservation Design Award from the California Preservation Foundation. Unfortunately, the once green pastures near the Water Temple are now being mined by a local quarry; however, future plans are to turn the land into a recreation area once the mining ceases. (Courtesy of Ario and Joyce Ysit.)

SUNOL VALLEY, 1996. This view of the valley, looking southeast, will hopefully remain unchanged for generations to come. Besides the mining operation, the land is primarily zoned for agriculture. It is owned by the San Francisco Water Department and considered a part of unincorporated Alameda County. (Courtesy of Ario and Joyce Ysit.)

ACROSS AMERICA, PEOPLE ARE DISCOVERING SOMETHING WONDERFUL. *THEIR HERITAGE.*

Arcadia Publishing is the leading local history publisher in the United States. With more than 4,000 titles in print and hundreds of new titles released every year, Arcadia has extensive specialized experience chronicling the history of communities and celebrating America's hidden stories, bringing to life the people, places, and events from the past. To discover the history of other communities across the nation, please visit:

www.arcadiapublishing.com

Customized search tools allow you to find regional history books about the town where you grew up, the cities where your friends and family live, the town where your parents met, or even that retirement spot you've been dreaming about.